IMAGES
of America

UPPER PITTSGROVE, ELMER, AND PITTSGROVE

Bonny Beth Elwell

ARCADIA
PUBLISHING

Published by Arcadia Publishing
Charleston, South Carolina

Printed in the United States of America

Library of Congress Control Number: 2013933845

For all general information, please contact Arcadia Publishing:
Telephone 843-853-2070
Fax 843-853-0044
E-mail sales@arcadiapublishing.com
For customer service and orders:
Toll-Free 1-888-313-2665

Visit us on the Internet at www.arcadiapublishing.com

*To my grandma June Hale Elwell, whose roots traced
three centuries of Upper Pittsgrove history, and to past
historians, whose preservation made this work possible.*

IMAGES
of America

UPPER PITTSGROVE, ELMER, AND PITTSGROVE

Dee Roe—
Thank you so much for sharing all of your knowledge of Daretown history with me. It is a joy to research together!

Young Beth Elwell

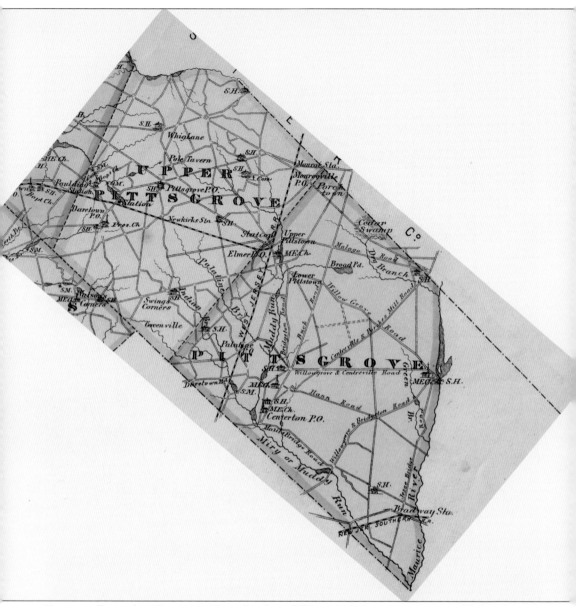

Known collectively as Pittsgrove Township from 1759 to 1846, the eastern region of Salem County later split into Upper Pittsgrove Township, the Borough of Elmer, and Pittsgrove Township. This 1876 map from Everts and Stewart's *Combination Atlas Map of Salem and Gloucester Counties* was published before the Borough of Elmer incorporated in 1893. The small communities of these townships were once dotted with churches, one-room schoolhouses, and railroad stations. (*Elmer Times.*)

ON THE COVER: A farmer sprays a field of potatoes. Farming potatoes was common in Upper Pittsgrove Township and Pittsgrove Township during the turn of the century, and hundreds of wagons filled with potatoes would gather at Elmer to be loaded onto the trains and shipped to cities far across the country. About 100 railroad cars of potatoes would leave Elmer each week during potato season. (*Elmer Times.*)

CONTENTS

Acknowledgments

Without the generous assistance of numerous people, this book would tell an incomplete story with only a handful of photographs. I am profoundly thankful for my fellow historians who assisted in this project, particularly Mark Foster who sifted through the archives of the *Elmer Times*; Olin Garrison, Ray Seibert, and James Eyler who provided images and research on Elmer; Charles Jansky, Mary Alice Creamer Stenberg, and Herb Wegner who provided Pittsgrove Township history and photographs; Elizabeth Myers and Dee Roe Williams who helped research Upper Pittsgrove history; Henry McAllister and Lou Ware who contributed the collections of photographer Frank Henry and historian Natalie Ware Johnson; the Pittsgrove Presbyterian Church which allowed me to peruse its archives; Steven Schimmel of the Jewish Federation of Cumberland, Gloucester, and Salem Counties and Jay Greenblatt of the Alliance Colony Foundation who shared sources on the Alliance Colony; and Tim Harple and the Woodstown Pilesgrove Library for providing E.W. Humphreys's photographs. Thanks go to all who shared photographs and knowledge with me, including the Cassaday family, Robert Widdifield, Carol Madiraca, Fred Harz Jr., Norman T. Robinson, Gary and Shirley Hitchner, Bill and Ginny Gantz, Jim Scott, Tim Darling, and Elizabeth Pitts. It has been a delight to research our community's history together.

I am also indebted to past historians who researched and preserved the history of Upper Pittsgrove, Elmer, and Pittsgrove, particularly Natalie Ware Johnson, Louella DuBois Keen Beirne, Jay Williams, Verna Corathers, Theodosia Foster, Edgar Charlesworth, and Ferol Ward.

Finally, I would like to thank my friends who provided support and sustenance, my mother for proofreading, my sister Amy for her patient help, my editor Katie McAlpin for her encouragement, and my God who is my strength and security.

The images in this volume appear courtesy of the *Elmer Times* (ET), the Greater Elmer Area Historical Society (GEAHS), James Eyler (JE), S. Olin Garrison (OG), Charles Jansky (CJ), Henry R. McAllister (HRM), Louis D. Ware (LDW), the Pittsgrove Presbyterian Church (PPC), the Woodstown-Pilesgrove Library Association (WPL), the author (BBE), and other individuals and organizations as noted.

INTRODUCTION

As morning fog highlights cornfields, orchards, cow pastures, and country villages, it seems that a remnant of the Garden State still remains in Upper Pittsgrove Township, the Borough of Elmer, and Pittsgrove Township. Here, families still live on land their ancestors settled 300 years before, and neighbors are often distant cousins.

Originally part of the West Jersey Colony, Salem County was first settled by Quaker John Fenwick, who bought the land that is now Salem and Cumberland Counties. Fenwick arrived at Salem in 1675 with a group of other settlers, including his daughter Priscilla and her husband Edward Champneys.

As Fenwick sold portions of his thousands of acres of land to fellow Quakers and other Englishmen, the eastern end of Fenwick's land became collectively known as Pilesgrove, named after Thomas Pile who owned 10,000 acres in that region. Pilesgrove originally included all of present-day Pilesgrove Township, Woodstown, Upper Pittsgrove Township, Elmer, and Pittsgrove Township.

As the 18th century dawned, a wave of pioneer settlers came to this region, which the original Lenni Lenape called Cohawken. Seeking refuge from persecution in New England and Great Britain, a number of Quakers and Baptists migrated here to the more lenient West Jersey colony. Elwells, Mayhews, Paullins, Dickinsons, Bricks, and Nelsons were some early Baptist settlers who gathered as the Pittsgrove Baptist Church, a branch of the Cohansey Baptist Church. One of these Pittsgrove Baptists was Joseph Champneys, a grandson of Edward Champneys. He was an early settler in the area known as Champneys Corner at the present-day location of Pole Tavern.

The Upper Pittsgrove community grew further when a widow named Sarah DuBois Van Meter came down from New Paltz, Ulster County, New York, with her sons and her DuBois nephews to inspect and purchase 3,000 acres of land in 1714. These descendants of French Huguenot and Dutch Reformed immigrants had heard there was land for sale in West Jersey and decided to invest. Another cousin of the Van Meters and DuBoises, Cornelius Nieukirk bought land along the Maurice River a few years later. These settlers were instrumental in the founding of the Pittsgrove Presbyterian Church, along with other immigrants from Great Britain such as the Johnsons.

When famine, war, and turmoil drove families from their homes in the Palatine region of Europe in the early 1700s, many Germans arrived in Salem County in search of better lives. The Hitchners and Richmans were two German families who populated this region and worshipped at the Friesburg Lutheran Church in the neighboring township. Their numerous descendants created two more communities, as the Richmans settled Whig Lane and the Hitchners settled Greenville (also known as Pennytown). Other prominent families, such as the Garrisons, Coombs, Swings, and Moores, also moved into the area at this time.

Spiritual renewal swept across the region during the 18th century. In the early 1740s, Rev. George Whitefield and other revivalist preachers brought the Great Awakening to the settlers, and the Pittsgrove Presbyterian Church was established. Soon afterwards, Methodism came to the region in the 1770s through the preaching of Bishop Francis Asbury and the conversion of

7

Benjamin Abbott, a reprobate-turned-preacher. Eventually, Methodist churches would crop up in almost every community in the region, but the Revolutionary War overshadowed the early days of the Methodist movement.

When the old township of Pilesgrove was split into two sections on December 6, 1769, the eastern section was renamed Pittsgrove Township and included both the present-day Upper Pittsgrove and Pittsgrove Townships. The township was named in honor of the British statesman William Pitt, who was a friend to the American colonies as they fought for independence. Living up to its Revolution-inspired name, Pittsgrove was ardently patriotic, mustering two companies of militiamen as the first two regiments of Salem County. These militiamen met to drill at the Pittsgrove Presbyterian Church and at the Pole Tavern, the new name of Champneys Tavern. North of Pole Tavern, the community of Whig Lane received its name from an altercation between the patriotic Whigs and the loyalist Tories.

In the newly established United States of America, Pittsgrove Township continued to grow, as taverns, mills, smithies, and churches sprang up in each community. Villages like Pittstown (later called Elmer), Centreville (later called Centerton), Olivet, Union Grove, and Willow Grove developed, each with their own mill, school, and Methodist church. Stagecoaches traversed the area, stopping at Pole Tavern, the taverns in Pittstown, and the Centerton Inn along the way. However, life was also hard for the newly independent Americans. The country's money was worth little, the soil was depleted, and many sons of the region decided to move their families west to Ohio, Indiana, and Illinois in search of new land. Fortunately, the discovery of marl in 1820 brought new life to the soil, and farming continued to be a primary occupation in the region.

On March 10, 1846, Pittsgrove Township was split a second time to divide Upper Pittsgrove Township from the remaining Pittsgrove Township. Then in 1867, Salem County gave Pittsgrove Township to Cumberland County, but Pittsgrove rejoined Salem County the following year. The railroad's arrival in the 1860s brought greater growth as farmers shipped tomatoes, potatoes, and milk to the cities. Train stations were built in communities that had once only been a crossroads, such as Newkirk's Station, Monroeville, Palatine, and most prominent of all, Pittstown, which lay at the border of the two townships. Two railroad lines converged in Pittstown, and as the railroad made it a center of commerce in the area, it grew to include factories, businesses, and its own newspaper. In 1893, Pittstown was incorporated as the borough of Elmer.

Meanwhile, on the eastern end of Pittsgrove Township just north of Bradways Station (now known as Norma), the Alliance Colony provided homes for displaced Russian Jews, forming the communities of Alliance and Brotmanville in the 1880s. After the Jewish settlers began moving away in the 1930s, this became Pittsgrove Township's largest African American community.

Following the stock market crash of 1929, the land and the lake near Union Grove, originally settled by the Parvins, Creamers, and Ackleys, were bought by the government and became Parvin State Park. Civilian Conservation Corps workers built cabins, planted trees, and rebuilt the dam. During World War II, the camp housed Japanese Americans who were relocating to South Jersey to work at the nearby Seabrook Farms. In 1944, it became a prison for German prisoners of war, who also worked as laborers for local farmers. Today, Parvin State Park is open to the public, allowing the residents of the township to enjoy the treasures of nature found in their local forests and waterways.

In the 1960s and 1970s, housing developments began to crop up in Pittsgrove Township, making it the fastest growing township in Salem County. New schools were built to accommodate the growth, and other changes came as well. However, today these townships still show their dedication to their agricultural past by preserving acres of farmland; the region remains one of the most agricultural of the county. Through the past 300 years, Upper Pittsgrove, Elmer, and Pittsgrove have experienced a rich history, and the heritage of these small-town communities shall be treasured for generations.

One

DARETOWN AND THE DuBOIS DESCENDANTS

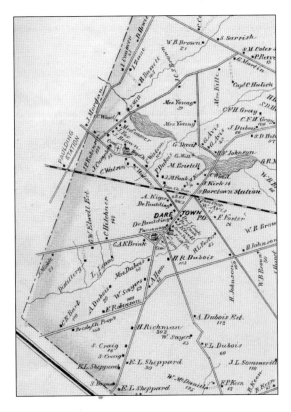

One of the earliest settlements, the region of Daretown was originally called by the name of the township, first Pilesgrove and then Pittsgrove. Here, the DuBois, Van Meter, and Nieukirk families settled, along with many other families. The village centers around the historic Pittsgrove Presbyterian Church and Pittsgrove Baptist Church, with additional settlements around nearby millponds of Fox's Mill toward Pole Tavern, Ballinger's Mill toward Aldine, and Slabtown Lake toward Woodstown. (ET.)

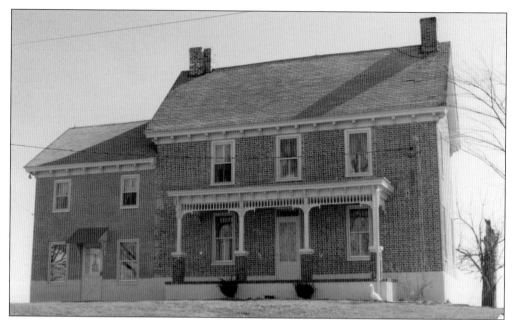

A remnant of the region's Quaker origins, this pattern-brick house was built in 1731 by David Davis, a grandson of Quaker aristocrat Dorothea Scott Gotherson. Davis served as Salem County justice of the peace and was instrumental in the founding of the Pilesgrove Friends Meeting. The Davis house was later owned by the Hitchner family, who removed the stucco to reveal the original brick in 1982. (Courtesy of Gary Hitchner.)

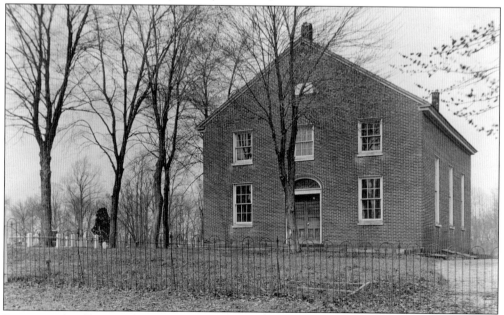

Baptist settlers began arriving in the 1690s. By 1729, they were meeting in a log cabin along Woodstown-Daretown Road. With Rev. Robert Kelsey serving as their regular minister, they were recognized as a branch of the Cohansey Baptist Church in 1743, and a frame meetinghouse was built to replace the old cabin. The Pittsgrove Baptist Church was officially incorporated in 1771. This old brick meetinghouse was built in 1844. (WPL.)

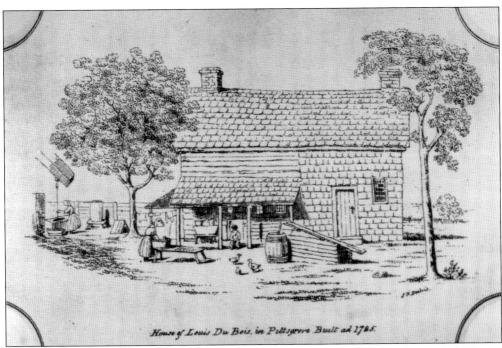

House of Louis Du Bois, in Pittsgrove. Built ad 1785.

The DuBoises, Van Meters, and Nieukirks moved in the early 1700s from New Paltz, New York, to Upper Pittsgrove. These pioneers descended from French Huguenots who had fled persecution in Europe and joined Dutch Reformed settlers in New York. Louis DuBois, his brother Barent, and their Van Meter cousins owned 3,000 acres of land around Daretown. Pictured here is an old sketch of Louis DuBois's homestead along Daretown-Aldine Road. (LDW.)

Cornelius Nieukirk was influential in the founding of the Pittsgrove Presbyterian Church, which originally met in a log meetinghouse close to Woodstown. Despite repeated requests that the Philadelphia Presbytery provide them with a minister, the congregation remained neglected for decades. Nieukirk died on August 17, 1744, and his gravestone in the old Presbyterian cemetery names him "one of the first and chief promoters / of the Gospel in this place." (BBE.)

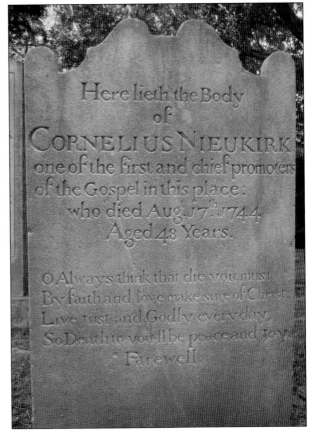

Here lieth the Body
of
CORNELIUS NIEUKIRK
one of the first and chief promoters
of the Gospel in this place:
who died Aug. 17th 1744
Aged 48 Years.

O Always think that die you must
By faith and love make sure of Christ
Live just and Godly every day,
So Death to you'll be peace and joy.
Farewell.

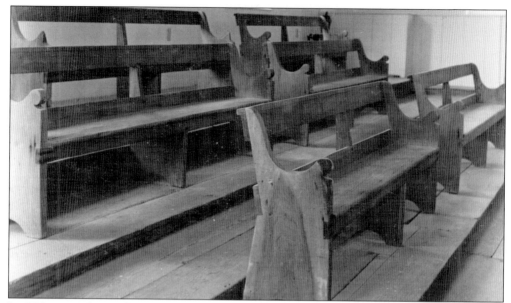

In 1740, evangelists Gilbert Tennent and George Whitefield visited Pittsgrove. Spiritual revival prompted the official organization of the Pittsgrove Presbyterian Church on April 30, 1741, under Rev. David Evans. Land was purchased from the DuBois family, and a log meetinghouse and schoolhouse were erected. It is said that these surviving benches (above) were used in that old meetinghouse. During the tenure of dynamic orator Rev. Nehemiah Greenman, the old brick meetinghouse (below) was built in 1767 to accommodate the swiftly growing congregation. As the United States began its fight for independence in the Revolutionary War, the settlers of Pittsgrove demonstrated quite a patriotic spirit, choosing their name to honor the American sympathizer William Pitt. The community and the church were fervently pro-Revolution. On September 20, 1775, a company of militiamen was formed under Capt. Jacob DuBois, meeting at this church for drills. (Above, PPC; below, ET.)

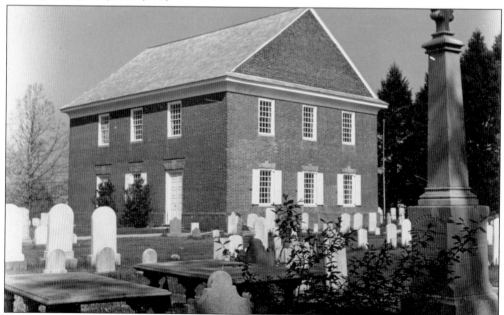

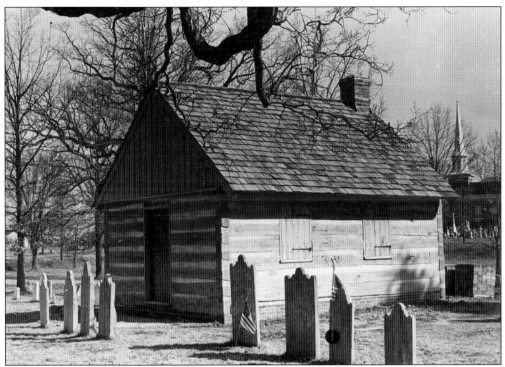

The Presbyterian clergymen also served as schoolmasters for young men who desired further education. Jonathan, Benjamin, and Uriah DuBois studied for the ministry under Reverends Evans and Greenman. During the 1780s, Rev. William Schenck taught at the Pittsgrove Log College; his students included historian Robert G. Johnson, Drs. Robert and James Van Meter, and Supreme Court judge John Moore White. This replica of the college was built in 1971. (ET.)

The Union School was built near the old Pittsgrove Presbyterian Church cemetery in 1803. Emma Sheppard, who attended here in the 1870s, made this sketch of the schoolhouse. The school also housed the first Pittsgrove Library, founded in 1813. Although those books were sold in 1833, the library was later reestablished in a small building that sits beside the Moses J. Paulding house, where it served as his doctor's office. (PPC.)

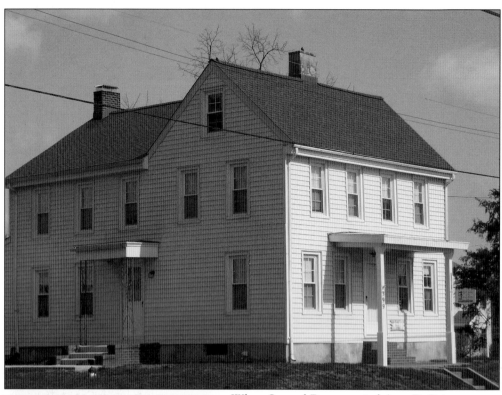

When Samuel Dare married Amy DuBois, he became a prominent citizen of Pittsgrove, serving as a Presbyterian church trustee and keeping a store in this home, built in 1795. After his death in 1838, the village was named Daretown in his honor. The area underwent another change of name when Upper Pittsgrove was split off from Pittsgrove Township to form a new township in 1846. (BBE.)

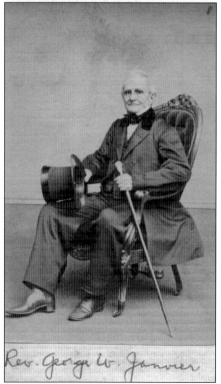

Rev. George W. Janvier

In 1812, Rev. George W. Janvier was installed as the pastor of the Pittsgrove Presbyterian Church. The church prospered during the following 47 years of his ministry. A revival transformed the community in 1842, and membership rose to 547. After Janvier's retirement in 1857, his son-in-law Rev. Edward P. Shields became pastor, and another revival swept through Upper Pittsgrove. (PPC.)

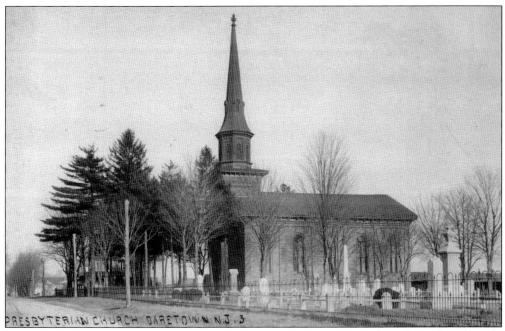

With its increase in membership, the Pittsgrove Presbyterian Church found it necessary to build a new church in the 1860s. Although construction was delayed by the Civil War, this brick building (above) was completed in 1867 with a tall steeple and a bell that could be heard five miles away. On April 15, 1867, the church was dedicated, but heavy rainstorms kept many people from attending. Throughout the region, dams broke and bridges were washed away. During the ceremony, the ceiling of the old church finally collapsed; the new church was apparently constructed just in time. Seen here around 1900, the steeple was originally painted rust red. The Jardine Tracker pipe organ (below) was installed in 1885. (Above, JE; below, HRM.)

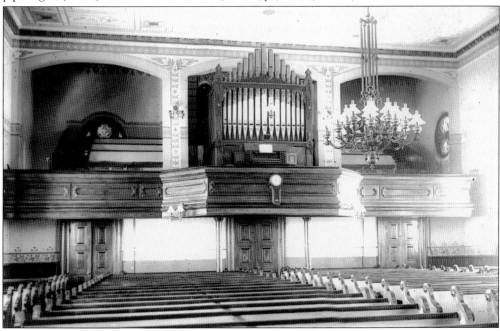

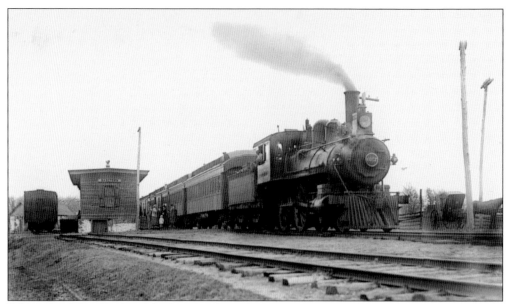

When the Salem Railroad laid tracks through Daretown in January 1863, new opportunities became available for the residents. The trains carried freight, milk, and passengers west to Salem or east toward Elmer. The station was located near the corner of Colson Road and Daretown Road (above). The station also served as the first post office, with John Krom as postmaster. For many decades, the railroad station agent was Jeremiah Foster, shown below inside the station assisting a passenger to purchase a ticket. Foster retired in 1906, and Frank C. Smith was the next station agent. From 1906 to 1923, Daretown was a center for potato shipping. The railroad fell into disuse in the 1940s as motor vehicles became more prevalent. (Above, HRM; below, WPL.)

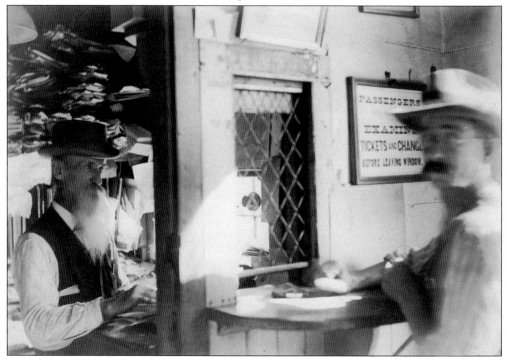

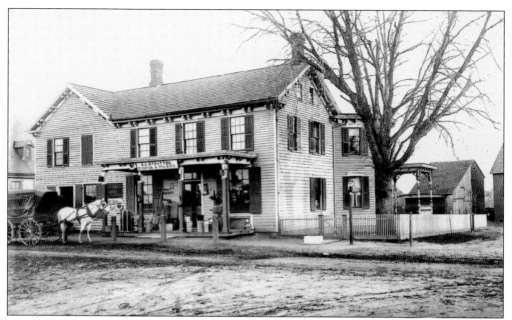

James Richman built this store in 1857 at the end of Woodstown-Daretown Road; later storekeepers included Joshua Lippincott, James Robinson, Samuel Allen, Jedediah DuBois, John Pierson, Clayton L. Stratton, William D. Barrett, and John Egan. Stratton was storekeeper for 13 years, and he also kept the post office here in the late 1890s. After Egan died in 1982, the store became a private residence until it was torn down. (HRM.)

At the corner of Woodstown-Daretown Road stands the Moses J. Paulding house (right), remodeled in 1871. Paulding was the local physician from the 1860s until 1894, when he was killed by a train. Samuel Elwell built the house on the left in 1738. It was the first home and doctor's office of Joseph Cook, whose son William invented an early ice-making machine in their machine shop. (HRM.)

Along the road from Daretown to Aldine at the southern border of Upper Pittsgrove is a lake that was once called Ballinger's Mill (above). A mill had been located here at least as far back as the mid-1700s. Some of the millers were John Craig, Joseph Van Meter, and Garrett Newkirk. From the 1860s into the 1910s, this gristmill (below, center) was run by Stephen R. Ballinger. The flour ground by Ballinger's Mill was well known for its quality. Sadly, in September 1940, a huge storm flooded the lake, washed the mill and the house away, and killed a woman and child. Ballinger's Lake and the mill property later belonged to Newton W. Grice, who donated it to the Boy Scouts. It now serves as a campground called Camp Grice. (Both HRM.)

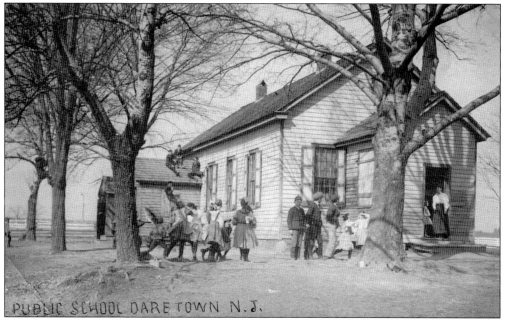

PUBLIC SCHOOL DARETOWN N.J.

Constructed in 1876 across the road from the old Presbyterian church, this schoolhouse served the children of Daretown for many years. On February 12, 1920, a chimney fire started during the school day, forcing the schoolchildren to evacuate as the schoolhouse burned to the ground. For a few months, classes were held in the old church and the manse while the students awaited the construction of a new building. (LDW.)

Amos Buzby and Samuel Morgan established the first Daretown creamery (left), located along Daretown-Aldine Road, in 1888. Louis Mack bought the creamery in 1891 and built the house beside it. The flooded stream provided the creamery with ice each winter. Later owners were Ira Champion, Cooper Oliphant, and Abbott's Dairies, which relocated near the railroad in 1912. The house and the back barn of the creamery remain standing. (HRM.)

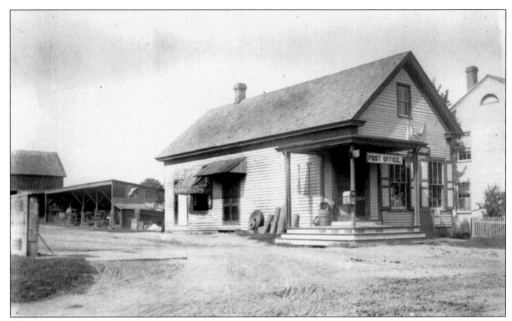

William Richman and Louis Johnson, who moved here from Whig Lane in the 1880s, originally ran this store on Woodstown-Daretown Road. Since Louis Johnson served as postmaster, the post office was also located here. In 1913, Benjamin Abbott and William Hawn bought the store. Hawn later became the postmaster, and his widow, Mary Hawn, served as the last Daretown postmistress until the Daretown Post Office closed in 1954. (HRM.)

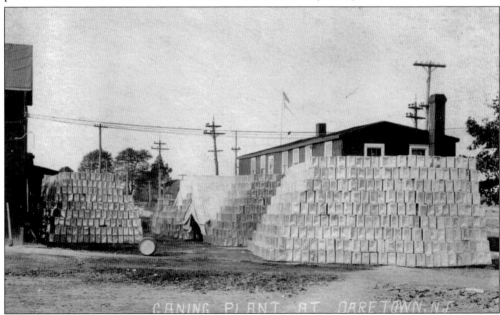

In 1887, William Richman sold out his interest in the store and built this canning factory down the road. The Imperial Canning Company annually produced 500,000 cans of Jersey Blue tomatoes, pumpkins, fruit, jellies, and other products. During World War I, over 100 employees worked here. After the cannery burned in 1924, Hawn's Wagon Works was rebuilt on the location. This view of the rear of the building shows baskets of produce stacked up. (LDW.)

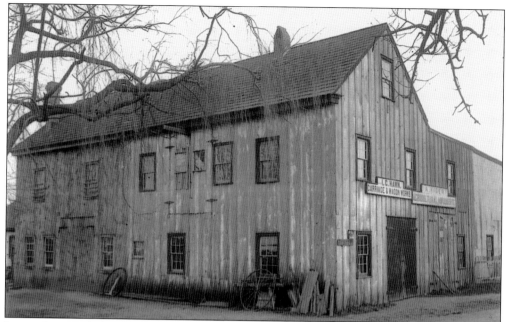

Located across from the store, this was the short-lived Hitchner and Colson canning factory around 1879. A few years later, wheelwright Isaiah Hawn and blacksmith Alfred Kiger moved into this building. Hawn's Wagon Works was a thriving business until it burned in 1924. After the fire, Hawn built a new shop across the street at the previous location of the Imperial Canning Company; the shop was later Hepner's Garage. (HRM.)

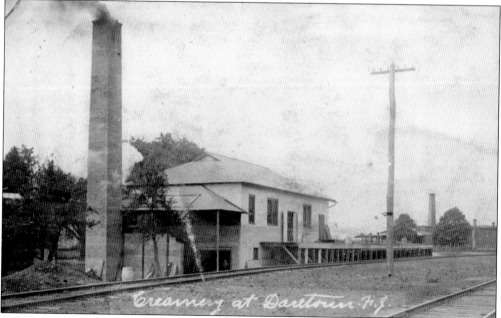

Abbott's Dairies moved its creamery to this building along the railroad tracks in 1912. In the distance can be seen the smokestack of the cannery. The creamery closed in 1930, and George Carleton turned this building into a blacksmith shop and his residence. In recent years, it has been torn down. (JE.)

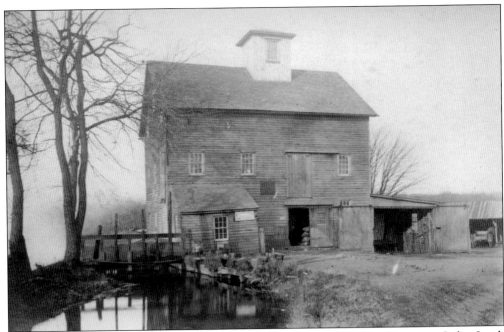

Along the road toward Pole Tavern, Samuel Elwell ran an early mill at Daretown Lake. Jacob Elwell or his son Jonathan erected this mill prior to 1825. Isaac Johnson and Samuel Dare were the next owners of the mill around 1830. They were followed by Frank Foster in 1856 and George Avis and his son William in 1860. Thomas C. and Charles P. Fox took over around 1882, running the mill until 1912. Fox's mill was run by steam power, visible behind the skaters on what was then called Fox's Pond (below). The mill was eventually given to Upper Pittsgrove Township by historian Frank B. Stewart's estate. Over a decade ago, local historian Jay Williams and Boy Scout Troop No. 60 restored the mill and built a replica waterwheel. It is now used by the Boy Scouts. (Both HRM.)

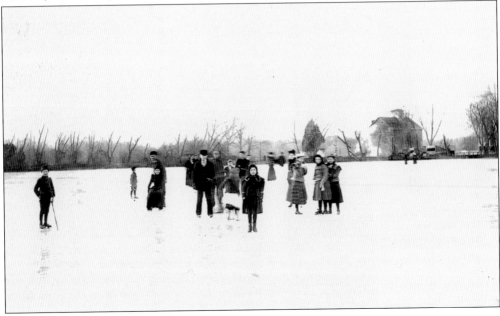

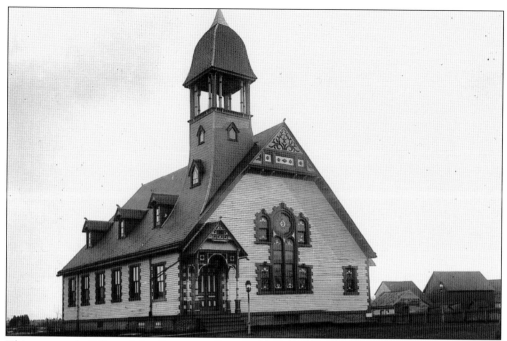

This current building of the Pittsgrove Baptist Church was constructed in 1893 when the old brick building along Woodstown-Daretown Road was no longer adequate. The original steeple shown here was struck by lightning in 1916. For decades, the church had a shortened steeple until the present-day steeple was erected in 2008. An addition with a gymnasium and classrooms was also added behind the building in the 1960s. (HRM.)

The Daretown School was built in 1920 as all the small schools in the township were consolidated. This school served the children from the Pole Tavern, Newkirk's Station, Shirley, Jefferson, and Walnut Grove schools in addition to the Daretown children. After the construction of the Upper Pittsgrove Elementary School in 1964, this was used for kindergarten through the third grade. Now, it is used by special needs children. (JE.)

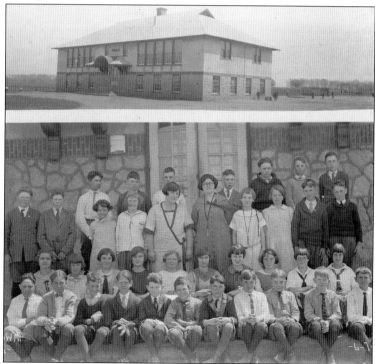

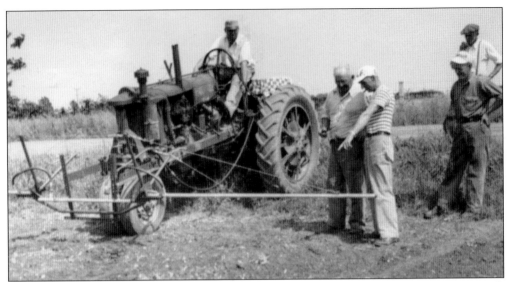

Agriculture has always been an important part of Upper Pittsgrove history. In this photograph from June 1949, Charles Nelson (third from left) from Elmer assists Norman T. Robinson (second from left) in the installation of a recently purchased weed sprayer. The sprayer was used to control the growth of weeds in cornfields on Robinson's farm along Woodstown-Daretown Road. (ET.)

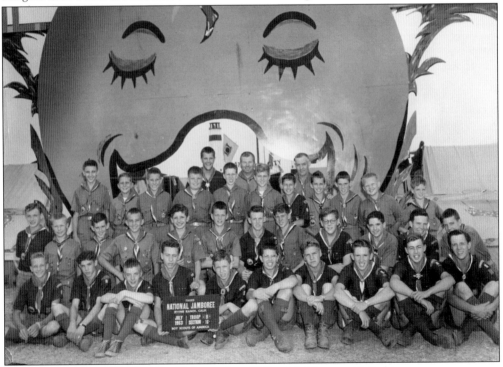

Daretown Boy Scout Troop No. 60 formed in 1943, with Norman T. Robinson as scoutmaster (back row, center). In 1953, the troop attended the third National Jamboree at Irvine Ranch, California, traveling across the country by train with over 800 other Scouts and their Jersey tomato gateway. The Boy Scouts of Troop No. 60 remain active, regularly traveling to Philmont Scout Ranch and each national jamboree. (Courtesy of Norman T. Robinson.)

Two

POLE TAVERN AND THE REVOLUTIONARY RALLIES

Pole Tavern was originally called Champneys Corner after Edward Champneys's descendants who ran the tavern. Revolutionary War militiamen drilled at this crossroads and patriotic Whigs clashed with loyalist Tories in Whig Lane to the north. Once a liberty pole was erected at the inn, the community became known as Pole Tavern, although the post office name was Pittsgrove. At Pole Tavern today, an old cannon still stands guard before the Upper Pittsgrove Town Hall. (ET.)

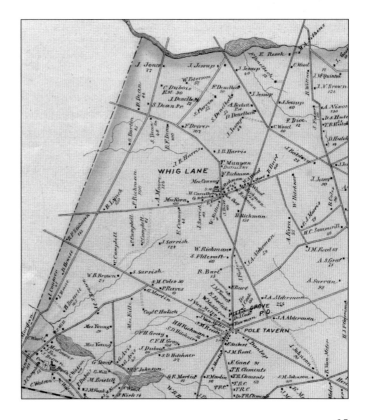

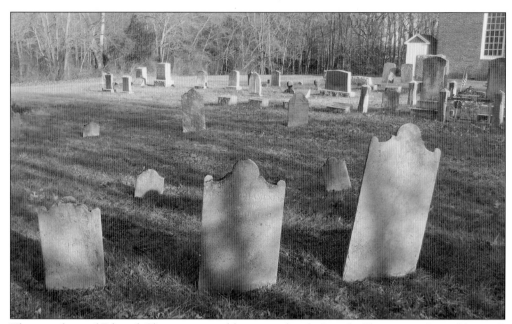

The grandson of Edward Champneys and his second wife, Joseph Champneys Jr. and his wife Christiana built a pattern-brick house on Old Salem Road in 1746, which is still standing in Pilesgrove Township. Later in life, the family moved to Pole Tavern and built another home near the circle, which passed to their son Joseph Champneys III. The graves of Joseph Champneys Jr. and Christiana Champneys (pictured) are at the Pittsgrove Baptist Church cemetery. (BBE.)

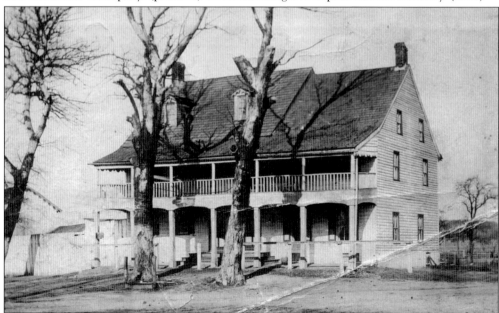

Joseph Champneys III, born 1740, built this inn before 1770. Originally called Champneys's Tavern, it was run after Joseph's death by his widow, Rebecca, and then by their son-in-law John Rambo. The inn and the community became known as Pole Tavern after the liberty pole in front of the tavern. Other inn proprietors included William Richman, Furman Mulford, Stephen Pearson, Ezekiel Rose, William Conklin, Jacob Deal, and John Alderman. (JE.)

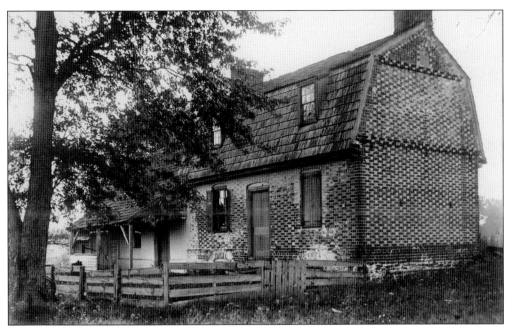

Jacob Richman, who built this house in 1746, was the son of Harman Richman and Mary Elizabeth Lucas, refugees from the famished Palatine region of Europe. He served as deputy surveyor of West Jersey. This house is located along Swedesboro Road between Route 77 and Glassboro Road, at the eastern side of the community of Whig Lane. (WPL.)

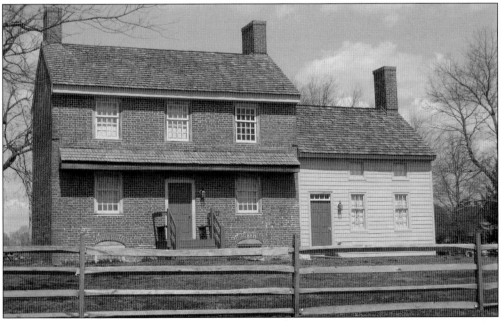

Michael Richman, another son of Harman Richman, constructed this brick house in 1764. During the Revolutionary War, there was a skirmish between the patriotic Whigs of the area and the loyalist Tories. When a British officer seized and occupied Richman's home, Whig troops surrounded the house in the night and captured the Tories inside. Whig Lane is named after these patriotic men. (BBE.)

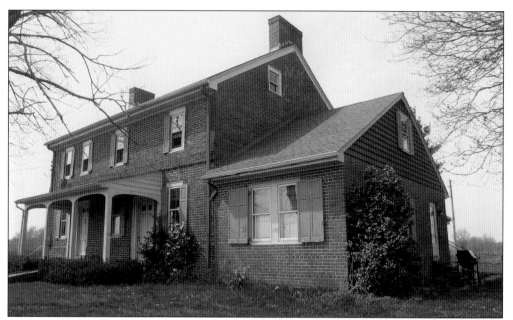

The Second Regiment of Salem County militiamen formed in Pole Tavern under the leadership of Capt. Cornelius Nieukirk. He and his men assisted in driving cattle to Valley Forge and fought at Mount Holly and at the Brandywine. Nieukirk remained in the military after the Revolutionary War, becoming lieutenant colonel of the 2nd Battalion in 1786. He built this house in 1783, which was later owned by Dr. Nitshe. (BBE.)

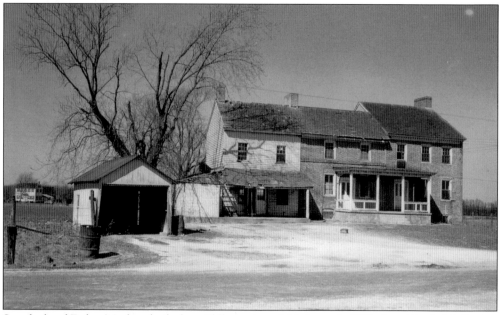

Stanford and Esther Mayhew built the middle section of this house in 1762 along Newkirk's Station Road at Route 40. Their son Eleazar Mayhew served in the Revolutionary War, and he and his wife, Sarah, added the right section in 1792. Their son-in-law Isaac Johnson and his descendants next owned the house. It is shown here just before John Seabrook restored it in 1950. (Courtesy of Elizabeth Myers.)

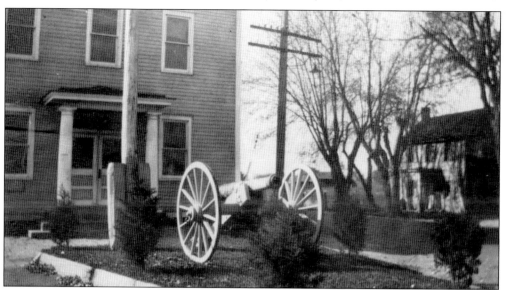

Made in Italy in 1763, this cannon is said to have been captured first by Napoleon before being captured by the British and then the Americans. It, along with 287 muskets and three other cannon, was purchased by the Salem Brigade for the Salem County arsenal after 1812. Behind the historic cannon can be seen the Upper Pittsgrove Town Hall (left) and an old Saltbox-style house that has since been torn down. (ET.)

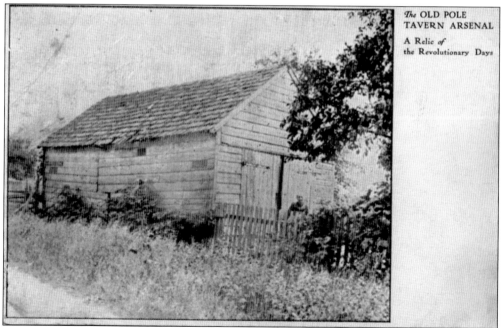

This old arsenal once stood near the present-day Wawa. It stored the weapons acquired between the War of 1812 and the Civil War. In late May 1889, veterans from Bridgeton arrived at Pole Tavern to seize the old cannon for their Independence Day celebrations. The elderly caretaker Rachel Richman (pictured) was unable to stop them, and the cannon was taken. This building was torn down around 1900. (JE.)

Around 1800, Champneys Rambo sold his grandfather Joseph Champneys's house to Joseph Cook. Cook was a wealthy man who owned a tannery near this site and served as deputy postmaster of West Jersey and justice of the peace. In this house one evening in 1824, Cook was shot and killed by an unidentified culprit, a murder that has never been solved. This house still stands along Daretown Road. (OG.)

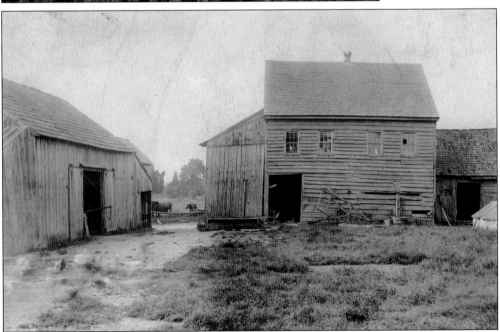

After Joseph Cook, other tannery owners at Pole Tavern included Joseph Ketcham, Elisha Heritage, and Henry Rouser before Gottlieb Kress took over in 1857. Kress was a German immigrant who operated the tannery for decades until his death in 1913. This photograph by E.W. Humphreys shows the tannery during Kress's ownership. (WPL.)

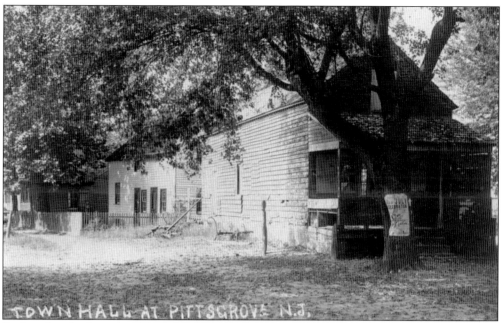

Said to date back to the 1700s, the Old Brown Store of Pole Tavern once stood on the site of the current Upper Pittsgrove Town Hall. During the Civil War, soldiers drilled in front of this store near two flagpoles. Some of the storekeepers included Jacob Hitchner, George M. Elwell, and Samuel Martin. The store apparently was also used as the town hall around 1900 before it was torn down. (JE.)

This c. 1876 map shows the tannery, wheelwright shop, blacksmith shop, harness maker's shop, inn, schoolhouse, and two stores. The general store at the present location of Wawa was built around the 1840s. Rachel Richman was one of the storekeepers, along with her husband, Henry H. Richman. Other owners included H. Clement Sweatman, Charles K. Richman, William Reeves, John Schade, and John Mickel. (ET.)

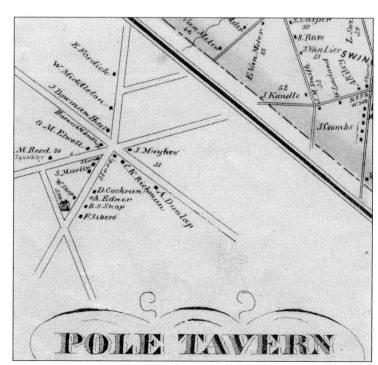

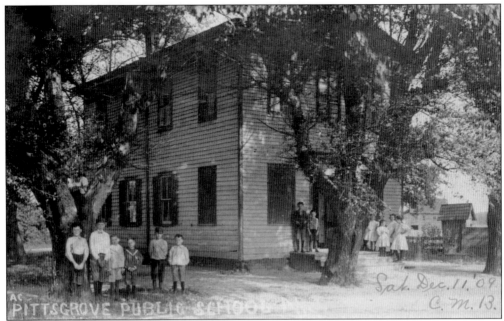

The Pole Tavern schoolhouse, also known as Centre Union School, was built in 1848. The top floor hosted first the Redman's lodge, then the Odd Fellows of Centerton, and also the Pittsgrove Clarinet Band's practices. When the students began attending the Daretown School instead, this building became the private residence of Ralph and Eleanor Shute until it was torn down in the 1980s. (JE.)

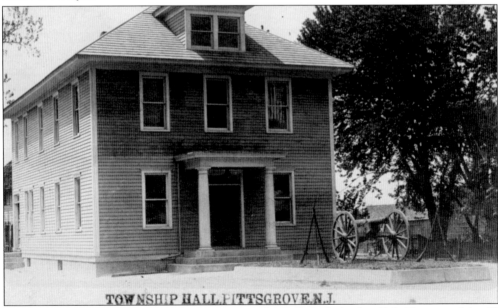

After two dozen years in Trenton, this cannon was finally brought back to Pole Tavern on May 17, 1913. The cannon was installed near the new Upper Pittsgrove Town Hall, which unfortunately burned down soon afterwards on March 10, 1914. This photograph shows the rebuilt town hall with the cannon in front. Still located at the town hall, the cannon has been enclosed in a frame structure since 1994. (ET.)

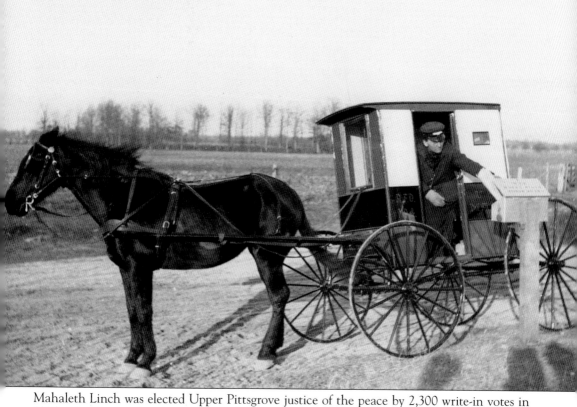

Mahaleth Linch was elected Upper Pittsgrove justice of the peace by 2,300 write-in votes in 1925. After the previous justice angered the community by holding court on Sunday, the Upper Pittsgrove community banded together to elect Linch completely without her knowledge. Linch won by a wide majority, but she did not find out until she received a letter with her commission as justice of the peace. Linch continued to serve as justice of the peace for over a dozen years, and she remained popular with the community, often lecturing offenders rather than sending them to prison. Shown here in 1904, she previously served as the rural mail carrier from 1902 to 1905. Passionate about women's rights, she suspected that her dismissal was due to her gender and traveled to Washington to protest. Linch and her husband lived in the farmhouse on Route 40 just east of Newkirk's Station Road, where she spent long days laboring at housework and farm chores, besides her duties as justice of the peace. (WPL.)

A descendant of New Sweden colonists, Anthony Nelson sold this 18th-century homestead on Daretown Road to his nephew Samuel Nelson, who married Elizabeth Champneys. Their son Joseph C. Nelson had a cotton factory and millpond back in the woods, which washed away in 1868. The house, remodeled in 1894, stayed in the family for centuries, passing from the Nelsons to Charles F.H. Gray, and then to Russell Lloyd's family. (PPC.)

North of Pole Tavern in Whig Lane, the first school was called Franklin Seminary; it was built in 1824 along Glassboro Road just west of the crossroads. This newer schoolhouse was erected in 1854 along Whig Lane Road toward Eldridge's Hill and was also used for a Sunday school. After it was no longer used as a schoolhouse, it became a private residence. (GEAHS.)

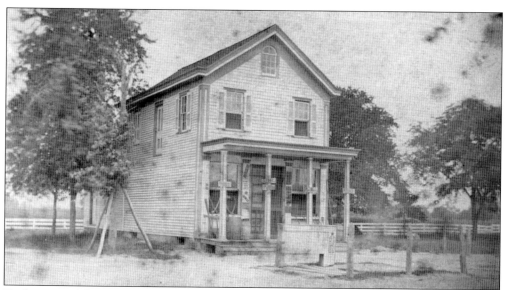

To the west of the intersection of Route 77 and Glassboro Road in Whig Lane, Jeremiah Wood ran a store in the early 1800s. Later, his son Charles Wood and grandson William A. Wood continued the general store business and built this store east of the crossroads around 1852 (above). William A. Wood lived across the street from the store in a house constructed in 1855. He served as a Salem County judge from 1882 to 1896 and owned around 1,800 acres of land. The Wood store has been converted to a private residence (below). (Above, courtesy of William Gantz; below, BBE.)

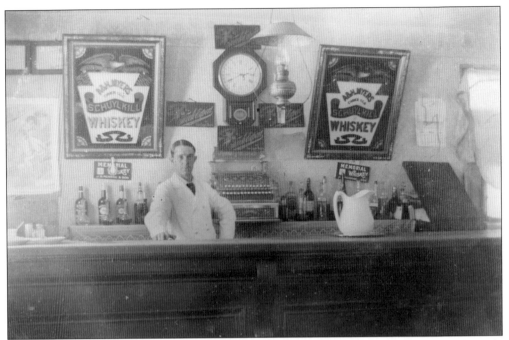

In this inside view of the Pole Tavern Inn, the bartender stands behind the counter. During the early 1900s, there was much conflict between the wets and the dries. When the Pole Tavern Inn burned down on April 5, 1918, some people suspected that the prohibitionists were to blame. (JE.)

When the Orthodox Presbyterian Church split from the Presbyterian Church in 1936 over doctrinal differences, a group of local Presbyterians organized as Faith Orthodox Presbyterian Church under Rev. Edward Cooper. After meeting for a few years in Upper Pittsgrove Town Hall, this building was constructed in 1941. It was expanded in 1973, 1991, and the 2000s to include a larger auditorium, classrooms, and a gymnasium. (Courtesy of the Orthodox Presbyterian Church Archives.)

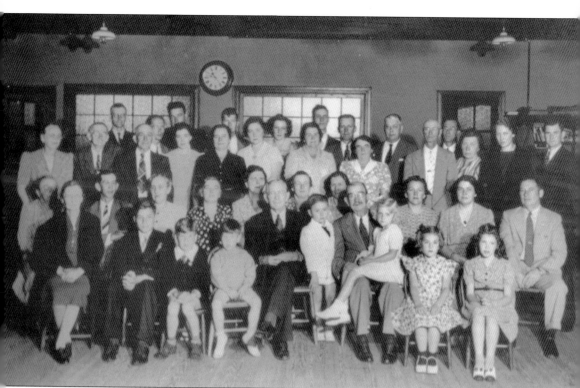

In 1888, twelve Upper Pittsgrove couples met for a May party at James T. Mayhew's home in Pole Tavern. The families continued to gather annually for over half a century. The attendees at this gathering on June 25, 1942, at the First Presbyterian Church of Elmer social hall are, from left to right, (first row) Lula Moore, Elbridge Bostwick, Herbert Bostwick, Leigh Bostwick, William Mayhew, Donald Charlesworth Jr., Jesse T. Heritage, Joan Heritage, Beatrice Thomas, and June Hale; (second row) Eva Moore, Isaac Prickitt, Leola Elwell, Elizabeth Newkirk Paulding, Florence Mayhew, Elizabeth Paulding Brooks, Marguerite Matlack, Ruth Brooks, Della Bostwick, and Rupert Matlack; (third row) Mary Mateer, Edgar F. Charlesworth, Albert D. Paulding Sr., Margaret Paulding Hale, Grace Prickitt, Olive Charlesworth, Helen Heritage, Geneva Newkirk Mayhew, Walter Brooks, Rev. Robert Strain, and Mrs. Strain; (fourth row) Otis Elwell, Donald Charlesworth, Albert Paulding Jr., Bernard Hale, Anna Charlesworth, Robert Brooks, Lothair Heritage, Clifford Mayhew, and Eugene Bostwick. (BBE.)

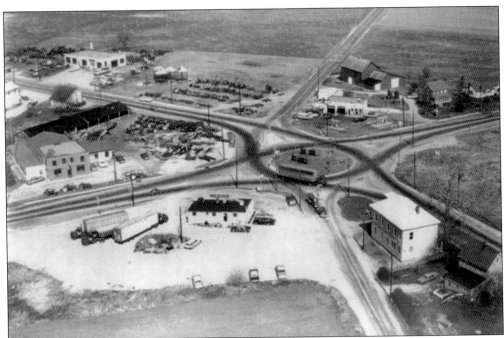

Around the Pole Tavern circle in this c. 1950 aerial view are (counterclockwise from the top left) the Langs' farm, Johnson Hurff's Case Equipment on Route 77, the Lacys' house, the Justices' store facing Route 77, Merle Foster's John Deere dealership along Route 40, the old Circle 40 Diner, Upper Pittsgrove Town Hall and John Schade's store along Route 77, and Edward Foster's home and gas station east along Route 40. (PPC.)

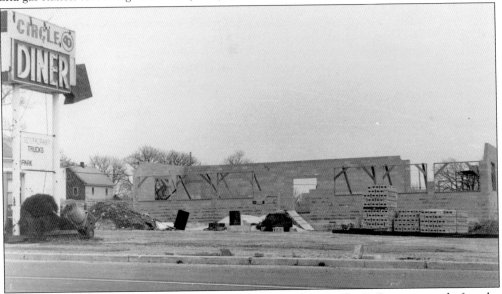

In the early 1940s, the first diner at Pole Tavern was called Circle 40 Diner, named after the traffic circle built in 1931. Glen A. Wentzell bought the property in 1944, and on April 8, 1952, the new Pittsgrove Circle Diner opened, shown here under construction. In 1976, Wentzell sold the diner, and it became known as the Point 40 Diner. The diner remains a community gathering spot today. (ET.)

Three

MONROEVILLE AND THE METHODIST MINISTERS

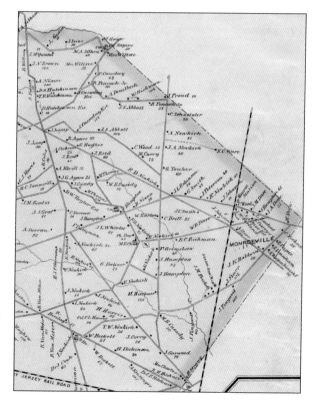

Monroeville and nearby Friendship both trace back to the Methodist Church. When John Murphy started holding Methodist classes at his home in 1772, the Friendship Methodist Church began as the earliest Methodist congregation in the region. In the 1850s, the Monroe Methodist Church formed at the eastern edge of Upper Pittsgrove. When the railroad came in the 1860s, the newly developing town took the name Monroeville. (ET.)

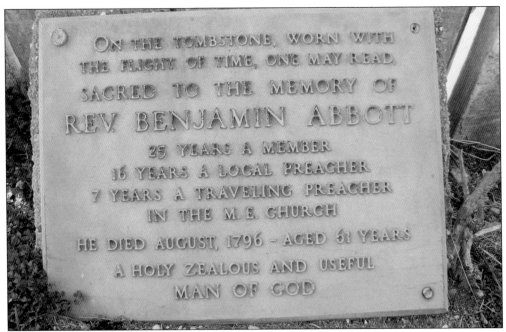

On October 12, 1772, Benjamin Abbott, a local laborer known for his drinking, swearing, fighting, and gambling, came to the home of John Murphy to hear the itinerant preacher Abraham Whitworth speak. Abbott left the meeting a changed man and devoted the rest of his life to preaching the gospel with enthusiasm throughout Salem County. This plaque decorates his tombstone at the First United Methodist Church in Salem. (BBE.)

The first log meetinghouse of Friendship Methodist Church was built on John Murphy's land, where the famous Methodist Francis Asbury preached in 1786, 1809, and 1814. A brick church was built in 1825 from bricks made on the nearby farm of Joast Nieukirk, who later willed his land to the church. In 1862, the old brick church was torn down, and this church was rebuilt on the same foundation. (ET.)

The Friendship School was on Friendship Road just north of Monroeville Road. The first school was built in 1815, but this one was constructed in 1858 and used until 1920, when it was moved onto John Wiltsee's farm as pictured below. These students of the Friendship School in 1913–1914 with their teacher Mary Riley are, from left to right, (first row) Mildred Kelly, Anna Frances Fithian, Loretta Thomas, and Cleora Newkirk; (second row) Clarence Wirth, Earl Elwell, Joseph Pedrick, Dudley Newkirk, Vernon Gantz, Hartley Newkirk, Frances Smith, Jonathan Fithian, Cortlyn Newkirk, Rudolph Franzen, Albertus Driver, and Harold Newkirk; (third row) Arleta Wiltsee, Ethel Peterson, Anna Pedrick, Evelyn Riley, Velma Thomas, George Fithian, Lorenzo Newkirk, Bea Newkirk, Anna Peterson, Charles Burgess, John Gantz, and Raymond Driver; (fourth row) Mary Riley, Roy Driver, Olive Johnson, Greta Burgess, Rebecca Gantz, Mildred Cassaday, William Thomas, Jane Reeve, Paul Schwertly, Asa Wiltsee, and Herbert Newkirk. (Both GEAHS.)

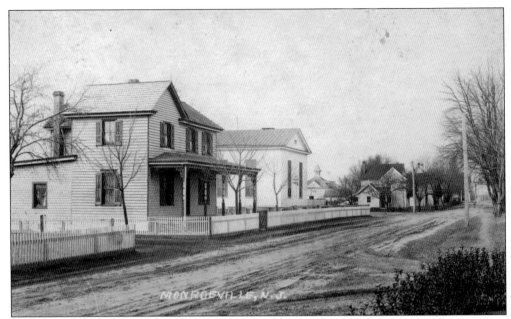

Methodists began meeting in the 1850s at the "Corn-and-Beans" schoolhouse on Dutch Row Road. Monroe Methodist Church was built nearby in 1858 and named in honor of Rev. Samuel J. Monroe. In 1892, it was moved one mile down the road to its present location in Monroeville (center), although the cemetery remains in Gloucester County. The church disbanded in 2012, and Harvest Bible Fellowship uses this building. (OG.)

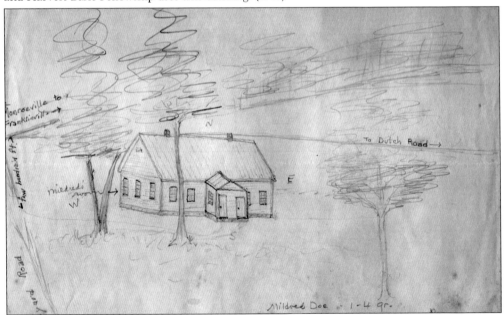

After the Corn-and-Beans schoolhouse burned in 1869, this Pinyard School was constructed where Pinyard Road and Fitchorn Road meet Monroeville Road. A tree swing provided entertainment for the schoolchildren during recess. On April 26, 1919, this school burned to the ground in the middle of the night, destroying everything inside. Mildred Doe, who attended the school before it burned, made this sketch. (GEAHS.)

James Money ran the first general store in Monroeville; it was in his home, located where the fire station is today. James MacFarland bought that old store and built this new store across the street, which sits on the corner of Monroeville Road and Three Bridges Road. MacFarland's son Randolph next ran the store, followed by his grandson Clair. Harmon Van Meter was the last proprietor of the MacFarland store. (OG.)

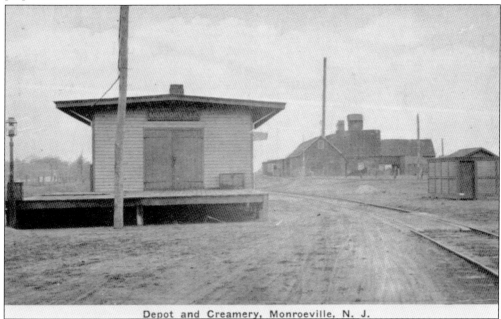

Depot and Creamery, Monroeville, N. J.

Randolph MacFarland and Henry J. Garrison established a creamery (right) around 1890 just north of the railroad station (left). They hired Edward Kraemer, a buttermaker from Sweden, and later began making ice cream to ship across South Jersey. Other employees included Ira F. Dare, Steward Dare, and Henry Creamer. MacFarland's brother Eugene ran a butcher shop nearby. Around 1915, MacFarland sold the creamery, which later burned in 1926. (OG.)

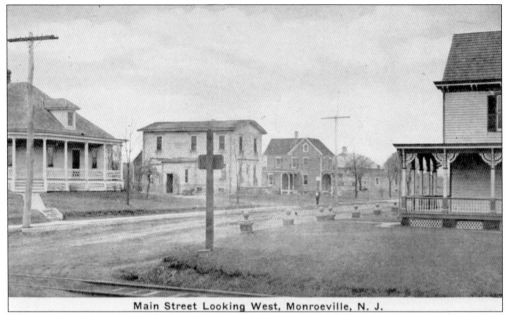

Main Street Looking West, Monroeville, N. J.

Henry J. Garrison, who was Randolph MacFarland's brother-in-law and a rural mail carrier, built the house beside the railroad tracks (right). Across the road stands Dare's Hall (second from left), which served as the Odd Fellows hall, store, ice cream shop, pool hall, and temporary school after the Pinyard School burned in 1919. The concrete building now serves as the Monroeville Post Office. (OG.)

PITTSGROVE PUBLIC SCHOOL.

The New Freedom School was built in 1830 on New Freedom Road, just north of Glassboro Road almost at the Gloucester County border. It was nicknamed the Brimstone schoolhouse. After it was no longer used as a schoolhouse, it was converted into a house until it was later torn down. (JE.)

44

Built in 1919 after the Pinyard School burned, the Monroeville School served children from all of the surrounding communities. Once the Upper Pittsgrove Elementary School was built, this school served only the fourth and fifth graders of the township. By 1991 it was no longer used as a school, and it now serves as the Turkish Muslim Center. (BBE.)

The Upper Pittsgrove Elementary School was built in 1964 on Pine Tavern Road. Children attended Daretown for kindergarten to the third grade, Monroeville for fourth and fifth grades, and Upper Pittsgrove for the sixth to eighth grades. After the Monroeville School closed in 1991 and the Daretown School became a special education school, this became the sole elementary school of the township. (ET.)

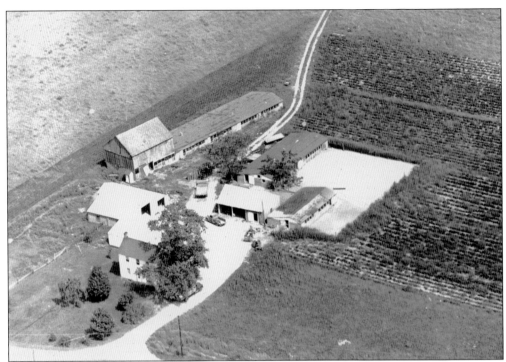

Around 1895, Harry Cassaday established this 70-acre farm on Pine Tavern Road (above). In the 1930s, his son Benjamin Cassaday took over the farm, raising vegetables and poultry (below). In the aerial view of the farm above, the three long buildings at the back of the barns were used for raising chickens. Most of these buildings and the old farmhouse have been torn down, except for the barn and shed at the center. Cassaday Farms has now grown to almost 2,000 acres, used primarily for growing vegetables. (Courtesy of George Cassaday.)

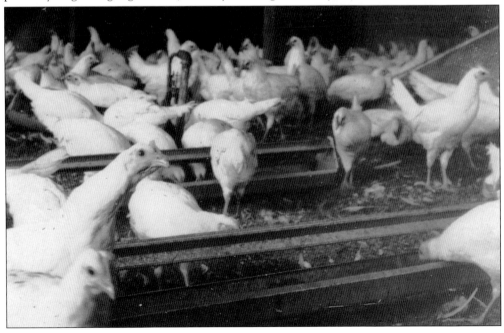

Sitting on top of the Cassaday Farms' 1950s Ford are three sisters, Vivian, Phyllis, and Elizabeth Lafferty, daughters of Mahlon and Zena Lafferty. Their mother worked for Cassaday Farms, helping to bunch asparagus. At that time, the Cassadays hired mostly local laborers, although foreign workers do the farmwork today. (Courtesy of George Cassaday.)

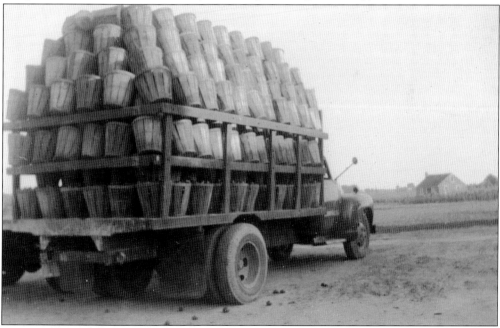

This truck is loaded with 500 baskets of tomatoes heading from Cassaday Farms to the Campbell Soup Company in Camden. Hundreds of trucks loaded with tomatoes would gather in Camden daily, waiting in line to be processed. During tomato season, all of Camden smelled like tomatoes. (Courtesy of George Cassaday.)

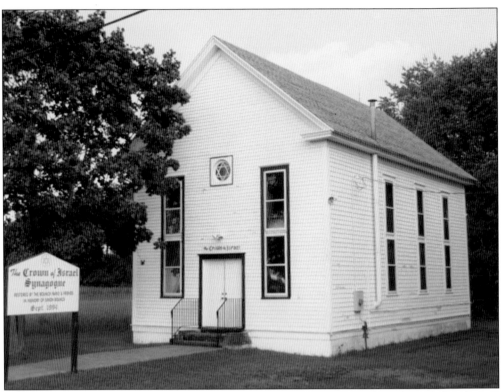

After a number of Jewish families
moved into the Monroeville area,
the Crown of Israel Synagogue
was built on February 7, 1914,
with Abraham Bolnick serving
as the first rabbi. The Bolnick
family still cares for the property,
and holds services for holidays
a few times a year. (OG.)

When the old Friendship Methodist
Church burned down in 1970, this
church was built to replace it at the
same location. The old cemetery lies
across the street from the church
at the corner of Friendship and
Island Roads. Worshippers still
gather every Sunday at this site
where Methodism first came to
Upper Pittsgrove Township. (ET.)

Four

SHIRLEY AND THE SWINGS, SCHOOLS, AND STORES

Settled by the Swing family in the late 1700s, Shirley was originally called Swing's Corner. When the community got a post office, the name was changed to Shirley after the heroine of a Charlotte Bronte novel. Most of this area east of Daretown, south of Pole Tavern, and west of Elmer is farmland, with schools and stores scattered about the crossroads of Shirley, Jefferson, Newkirk's Station, and Walnut Grove. (ET.)

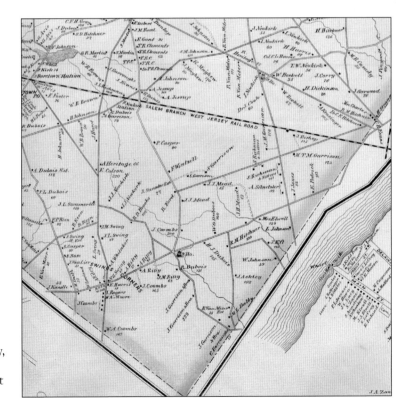

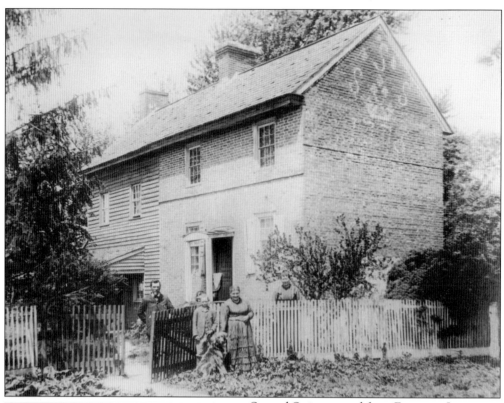

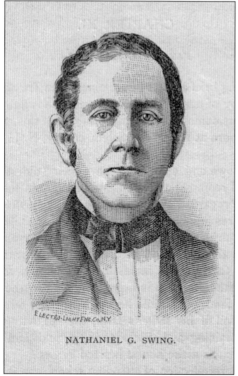

ELECTRO-LIGHT ENG. Co. N.Y.

NATHANIEL G. SWING.

Samuel Swing moved from France to Long Island in 1755, where he married Sarah Diament before moving to Upper Pittsgrove. The Swings' pattern-brick home was built in 1775. Swing served in the Revolutionary War, and his son Abraham served in the War of 1812. He was an elder at the Pittsgrove Presbyterian Church and an early abolitionist, helping hide escaped slaves in 1797. (Courtesy of Carol Madiraca.)

Abraham Swing's son Nathaniel G. Swing built a house in 1821 just down the road from his grandfather's house. He was a prominent man of the area, serving as a major in the Army and as a New Jersey state assemblyman. Swing also owned a general store and a chair factory near his home and was a trustee of the Pittsgrove Presbyterian Church. (Courtesy of Carol Madiraca.)

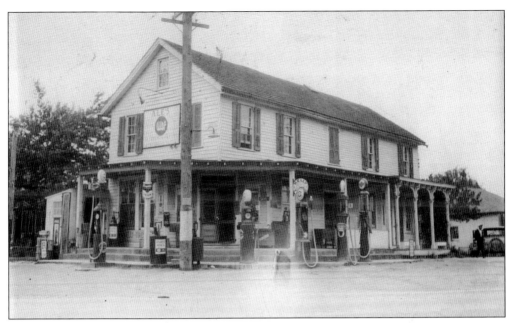

This store at Shirley Road and Route 77 was the post office in 1875 when the name Shirley was chosen. Millard F. Riley was the storekeeper and postmaster, and the novel *Shirley* was said to be his wife's favorite. George Haaf ran the store from 1907 to 1910. Other storekeepers included David Shultz, John Drake, William Isaacs, Horatio Carman, and Frank and Sherman Ale. (Courtesy of Alice Wilson.)

Samuel Garrison, born in 1799, bought 600 acres of land around the 1860s in the vicinity of Shirley, Jefferson, Garrison, and Burlington Roads. Here, he and his descendants farmed and built homes, lending their name to Garrison Road. He was active in the community, serving as Salem County freeholder in 1849 and as New Jersey assemblyman in 1866. (OG.)

The Old Washington School was located just west of Shirley Corner. It was built in 1829 to replace an even older schoolhouse from the 18th century. This school was used until 1900, when it was moved over to make room for a new schoolhouse. In 1923, this school was demolished. (ET.)

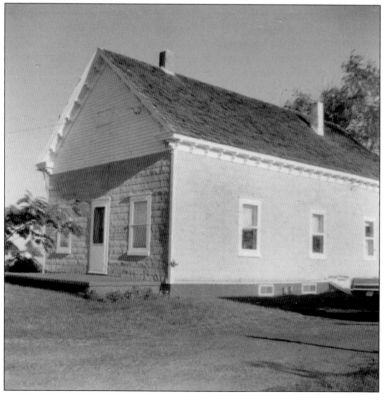

Originally constructed as the Shirley Union Chapel, afternoon services were held here by Rev. John Ewing, who was the Pittsgrove Presbyterian Church pastor from 1885 to 1901. In 1900, the chapel was moved across the street to be used as the new Shirley school. When the children began attending the new Daretown School in 1920, it was converted into a home and still stands on Shirley Road today. (GEAHS.)

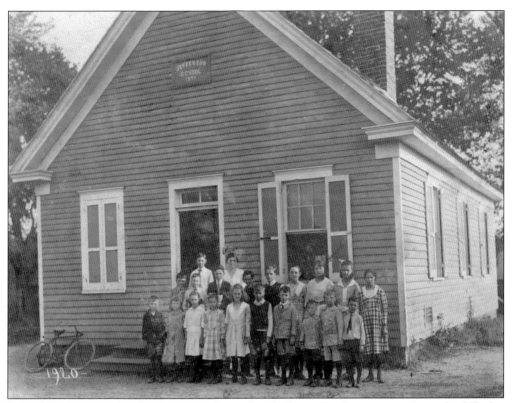

East of Shirley, an early school was once located on Jefferson Road a quarter mile south of Shirley Road. The next Jefferson school was built at the Shirley Road–Jefferson Road crossroads in 1843 and refurbished in 1869. This Jefferson schoolhouse was built in 1895. Pictured here in 1920, just before the students transferred to Daretown School, this building burned in 1927. (GEAHS.)

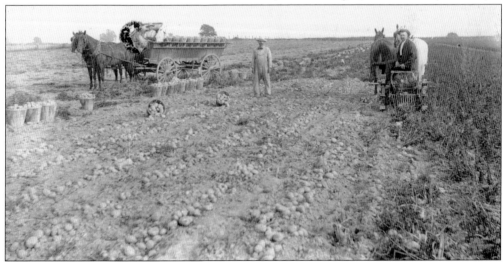

Potatoes were an important crop in this region around the turn of the 20th century. In this photograph by Hubert S. Foster, farmworkers on the Newkirk Van Meter farm dig up potatoes with an O.K. Champion digging machine in August 1905. The farm averaged 500 pounds of potatoes per acre. (JE.)

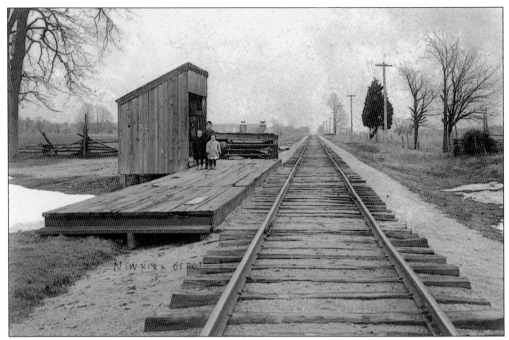

After the railroad crossed over Route 77 heading east toward Elmer, Newkirk's Station was the next stop for the trains. Newkirk's Station Road is named after this train station that once stood along the road. This photograph by Frank Henry shows Newkirk's Station at the turn of the century. (HRM.)

At the crossroads of Newkirk's Station Road and Route 77, a professor John Rose once taught young men around 1820. Rose also wrote an arithmetic textbook, which was used in schools throughout South Jersey. Later, the Union School (pictured) served Newkirk's Station until 1920. After being used as a private residence for several decades, it was torn down around 2005 and a new house was built on the site. (GEAHS.)

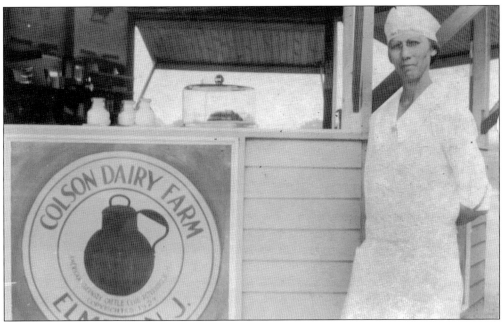

Maiden sisters Sarah and Jessie Colson ran a 220-acre dairy farm along Colson Road near Route 77 in the 1920s. After their father died in 1921, Jessie Colson took charge of the dairy while her sister Sarah (above) handled the housework. The Colsons sold fresh milk from their Guernsey cows at the roadside stand pictured below. They would sell around 50 to 75 bottles of milk a day at this stand. The Colson sisters were Quaker, and both attended Swarthmore College. Jessie also had a degree in biology from the University of Philadelphia. In 1893 she spent eight months at the Chicago World's Fair, acting as superintendent of the New Jersey agricultural exhibit. Sarah Colson, who later married Fred Blencowe, served as a Salem County committeewoman and later as a New Jersey state committeewoman. (Both OG.)

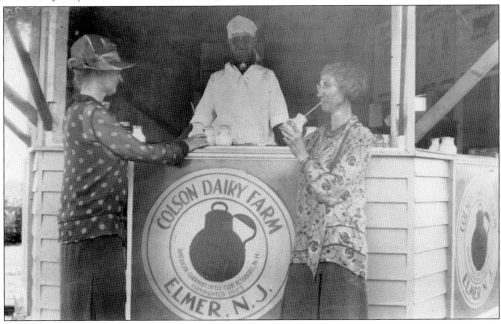

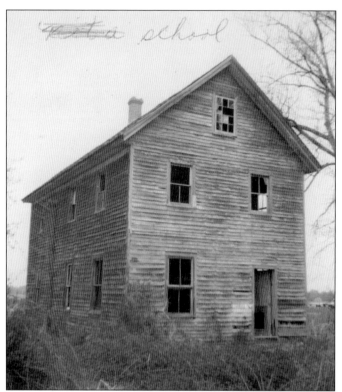

At the spot where Burlington Road crosses Route 40, a triangle of land was the site of the Walnut Grove schoolhouse. When a newer school was built in 1906 to replace the old one, this building was moved to John Bishop's farm across Route 40 to be used as a tenant house. The old school (left) is pictured with the additional second floor and back addition that were added by Bishop. Edna M. Parker (below) taught school here in 1899. The second schoolhouse was abandoned once the Daretown School and Monroeville School were built, and it was also moved to Bishop's property to be used as a tenant house. (Left, GEAHS; below, ET.)

Five

ELMER AND THE
TRAINS THROUGH TOWN

Located between Upper Pittsgrove and Pittsgrove, this town's early names included Cohawken, Ticktown, Terrapin Town, and Pittstown. Beginning as a small community featuring two taverns, mills, blacksmith shops, and various residences, it grew into a center of commerce once the railroad came through in 1861. The town was renamed Elmer in the mid-1800s after local judge Lucius Quintus Cincinnatus Elmer, and was officially incorporated in 1893. (ET.)

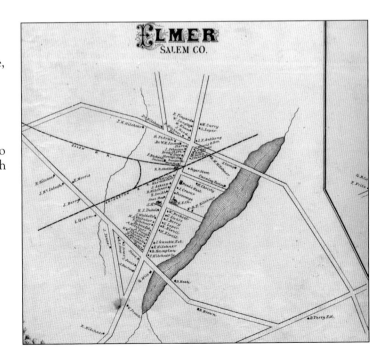

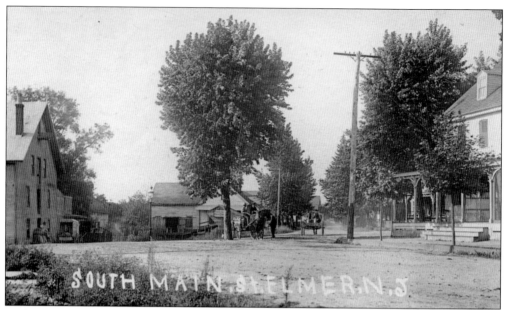

In the 1700s, two stagecoach routes crossed in south Elmer. One ran south from Woodbury to Bridgeton along North and South Main Streets and Centerton Road. In this photograph, South Main Street crosses Salem Street, which was a section of the other stagecoach route from Alloway to Glassboro. Two old buildings, the gristmill to the east (left) and the old tavern to the west, can be seen. (JE.)

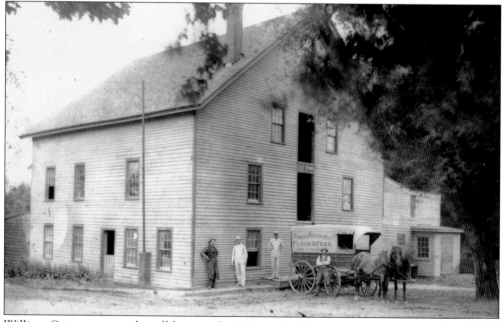

William Craig ran an early mill here in the 1790s. After his death, his widow, Letitia, married William Murphy, who sold the mill and lake property to John Pimm in 1803. Pimm rebuilt this mill, which was next owned by Isaac Johnson. Johnson and John Elwell owned a large portion of Elmer. The next millers were Johnson's son John and grandson William. The mill was torn down in 1941. (JE.)

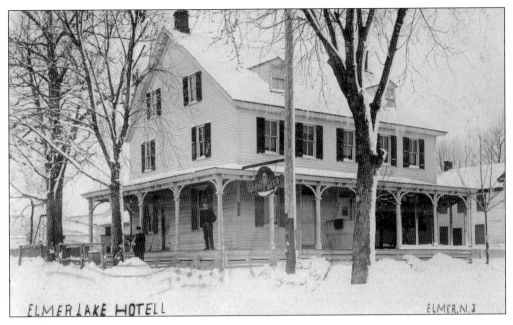

ELMER LAKE HOTELL ELMER, N.J.

Two early taverns at the north end of Elmer were the old red tavern at the Sunoco corner and another at Dodge's corner. Isaac Johnson built this tavern at South Main and Salem Streets in 1818. It is said that a path worn between here and the one at Front Street formed South Main Street. After nearby landowner John Elwell sold his extensive property to David Hitchner in 1827, Hitchner and his sons began selling plots to incoming settlers, and South Main Street gradually became more populated as the town developed. The tavern, which was later called the Elmer Lake Hotel, was converted into a retirement home in the 1950s. (Above, JE; below, ET.)

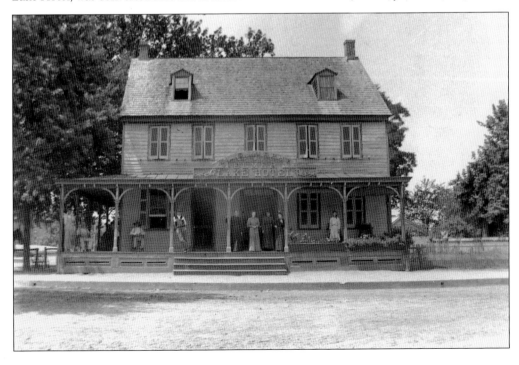

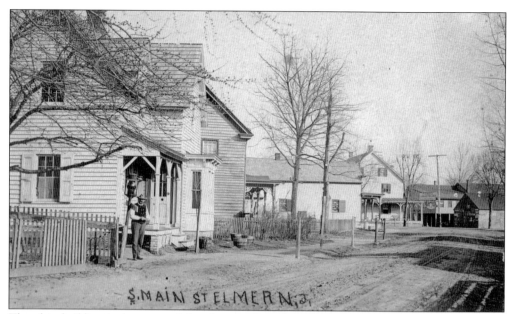

S. MAIN ST ELMER N.J.

The white building in the center of this photograph was Joseph Jones's store at the lower end of town, facing the mill. Behind the store can be seen the inn. The first post office in town was kept in the home of John Johnson from 1844 to 1858; Joseph Jones next ran the post office at his store until 1861. Later storekeepers included William Johnson, Samuel Christy, and David Nichols. (JE.)

Built in the late 1700s, this was the home of blacksmiths John Mayhew in 1843 and David V.M. Smith in 1852. A blacksmith shop stood beside it where Broad Street meets South Main Street. Smith was appointed postmaster in 1861, but after he was killed in the Civil War at Gettysburg, his widow Elizabeth Smith became postmistress. She and her son Rufus W. Smith also kept a store here. (ET.)

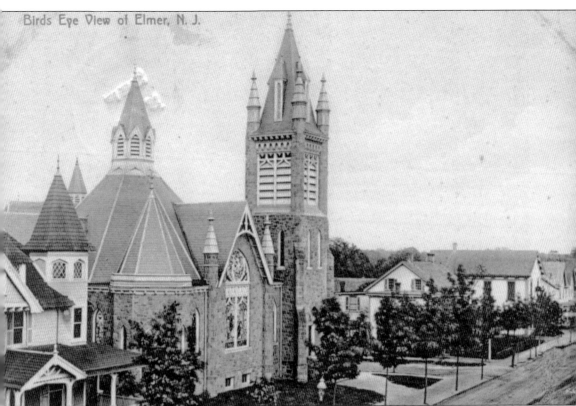

Birds Eye View of Elmer, N. J.

The earliest church in Elmer began as a Methodist Sunday school in 1834. Then, in 1844, the first Pittsgrove circuit parsonage was built at the current location of First National Bank. The original frame building of the Elmer Methodist Church was erected in 1868; it now serves as the church fellowship hall. This Gothic-style building was constructed in 1896, with the parsonage built to the left of it. To the right of the church can be seen, from left to right, Daniel Christy's funeral home (now Adams Funeral Home), the Temperance Hall, and Pfeffer's Bakery. (JE.)

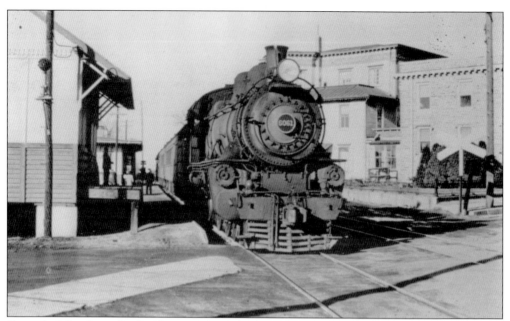

Once the West Jersey Railroad passed through Elmer in 1861, the town became a bustling center of commerce. Near where State Street meets South Main Street, the railroad branched off in 1863 into an extension heading toward Salem. This engine is heading south from Woodbury along the Bridgeton line, between the train station for passengers (back left) and the Garrison Building. (JE.)

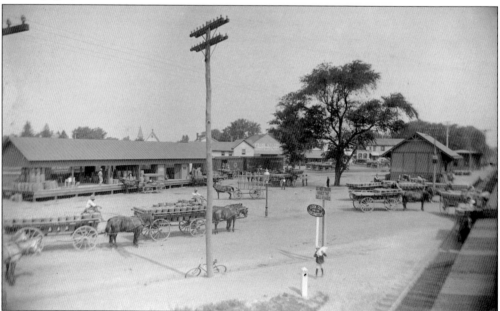

Looking north toward State Street from Broad Street, the flat-roofed passenger station is barely visible in the distance (right) while the freight station (left) stretches along the Salem line, where boxcars (center) await the next load of potatoes. Behind the freight station can be seen the rooftops, from left to right, of the original First Presbyterian Church of Elmer building, the *Elmer Times* building, the Madara house, and Frank Sturr's hardware. (ET.)

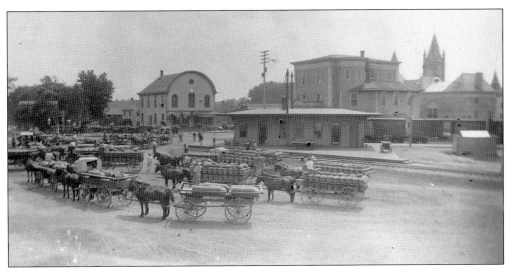

Wagonloads of potatoes stretch from the train station (center) to Reed's Hall (left) on South Main Street. Reed's Hall was built by James N. Reed in 1875 and housed many different businesses, including Child's store in 1909, followed by the American store. The diverse uses of the upstairs included shows, church meetings, a sewing factory, and roller-skating. The building currently serves as the Hangar, a social center for youths. (ET.)

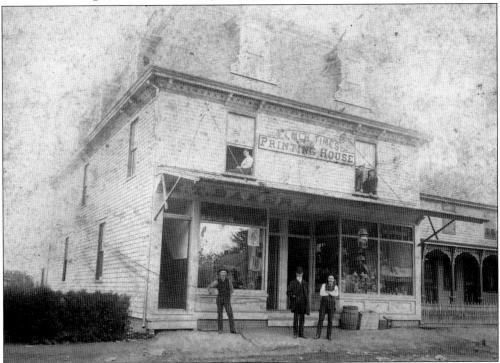

The Elmer Masonic Lodge No. 160 was constituted on February 17, 1887. By August, lodge member Harry Baker constructed this three-story building, which contained a drugstore, a furniture store, a public hall, and a lodge meeting room. The Baker Building also was the headquarters of the *Elmer Times* for two years, which moved here from Elmer and Center Streets a few months after Samuel Preston Foster became the editor. (ET.)

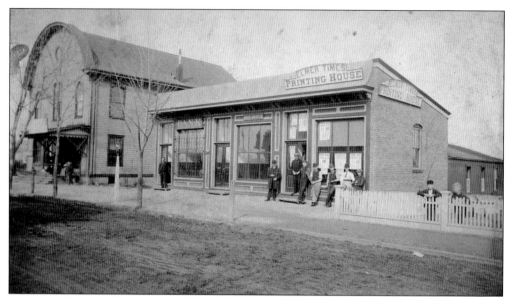

In September 1889, the *Elmer Times* moved to this building to the right of Reed's Hall. This building also housed a branch of the Atlantic City Bank and the post office, which moved here from the Smith house. This was later the site of Scrubby's Pool Hall and Smoke Shop. (ET.)

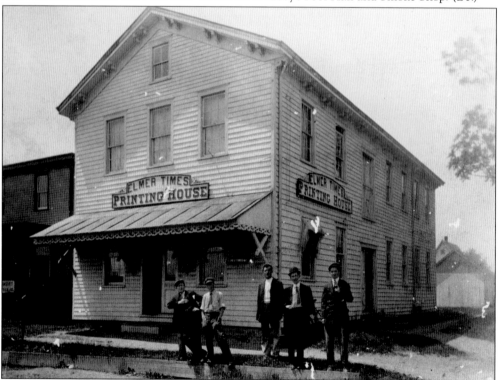

In 1891, land was purchased to construct a permanent building for the *Elmer Times*. The following January, this building on State Street was completed. Standing in front of the building are, from left to right, Charlie Pogue, Preston Samuel Foster Sr., unidentified, Edgar Charlesworth, and unidentified. (ET.)

Following in his father's footsteps, Preston Samuel Foster Sr. (left) and his wife, Amy Foster, took over as editors of the *Elmer Times* in 1915. His aunt Theodosia D. Foster (right) also served as associate editor of the newspaper beginning in 1891. She wrote a history of Elmer in 1909. (JE.)

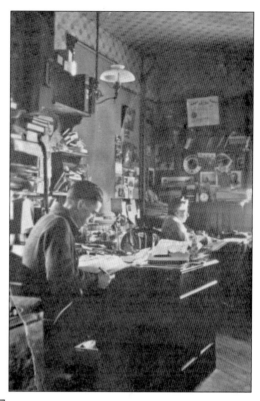

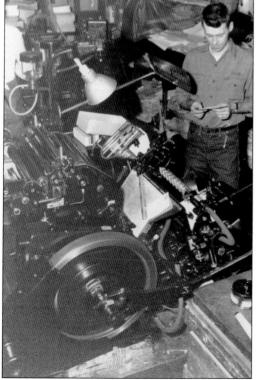

After Preston Samuel Foster Sr.'s death in 1981, his son Preston Samuel Foster Jr. was the next editor of the *Elmer Times*, seen here examining his new Heldelberg printing press in 1957. When he died in 1991, his daughter Pamela Foster Brunner took over, followed by his sons Mark and Preston Foster who continue to publish the *Elmer Times* weekly. (ET.)

Elmer's earliest-known school was located on Front Street and was called the Lodge schoolhouse since the Pittstown Masonic Lodge used it for meetings from 1816 until it burned in 1832. That school was rebuilt and used until 1850. Then this school was built on South Main Street. It was used until 1884, when it was moved between State Street and Front Street to be used for storage. (BBE.)

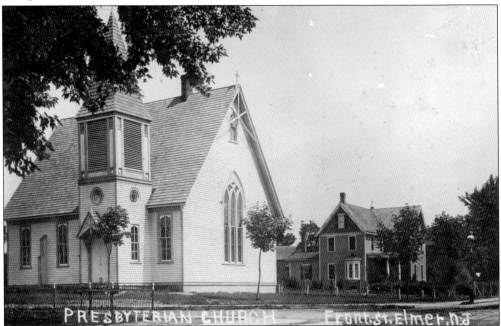

The First Presbyterian Church of Elmer formed as a branch of the Pittsgrove Presbyterian Church in 1879, meeting in Reed's Hall under Rev. William A. Ferguson. This building was dedicated in 1881; it stood facing Front Street. In 1923, this church was torn down, and the present building facing Chestnut Street was erected. (OG.)

Built in 1886 on South Main Street to replace the old frame elementary school, this also became a high school in 1894. An addition to the front in 1914 made room for more elementary classrooms. When the high school closed in 1918, students went to other nearby high schools until the Arthur P. Schalick High School was built. After the current elementary school was built in 1960, this building became the borough hall. (WPL.)

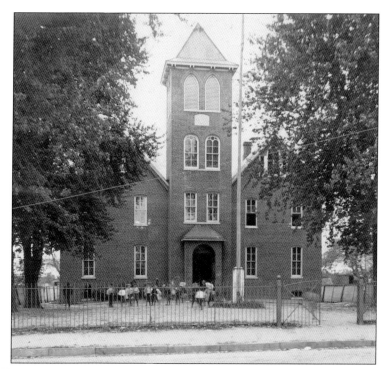

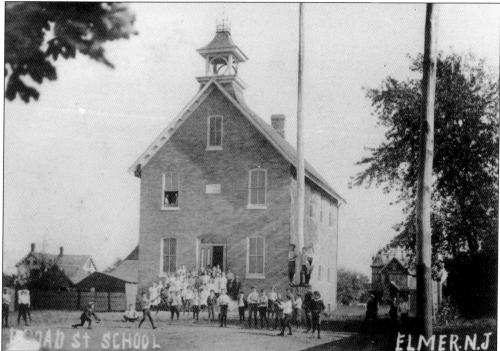

This school was built in 1898 at 330 Broad Street for elementary students. Once it ceased being used as a school in 1928, it became the Veterans of Foreign Wars hall. When a fire blazed through the building in 1958, it was converted into a private residence. After a second fire, it was remodeled into a one-story house. Finally it burned a third time, and it was razed on March 11, 2013. (JE.)

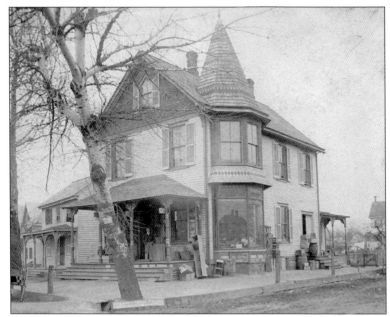

The first store at this corner of North Main and Front Streets belonged to Joseph Jones in 1846. After he relocated to lower Elmer, Isaac and Clinton Johnson ran it until they built a new store across the street. James Reed and his sons were the storekeepers from 1868 until William Usinger bought it in 1887. When Usinger built this new Victorian-style building (above), the old store building was moved down Front Street, where Frederick Harz Jr. uses it as the main building of the tire shop. In 1941, brothers Raymond Dodge Jr. and Alden Dodge purchased Usinger's store, and it has been called Dodge's Market ever since. After years as a small grocery (below), the store has recently been sold and remodeled as the New Dodge's Market. (Both ET.)

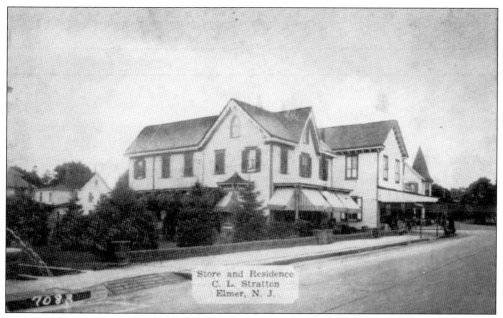

Isaac and Clinton Johnson, grandsons of the Isaac Johnson who ran the inn, built this store in the 1870s when they moved across the street from Usingers. It was next run by Clayton L. Stratton, who moved here from Daretown in 1909. Stratton's store was later torn down, and the Sunoco gas station now stands on this corner. (OG.)

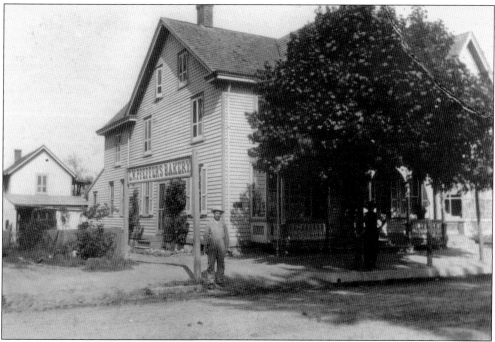

Casper Pfeffer immigrated to America from Germany in 1861, served in the Civil War for three years, and opened a shoe shop on South Main Street in 1872. Pfeffer's son George Washington Pfeffer built a large brick oven in the rear of this house in 1894, and Pfeffers Bakery began. His son George C. Pfeffer and grandson George C. Pfeffer Jr. continued the business. (JE.)

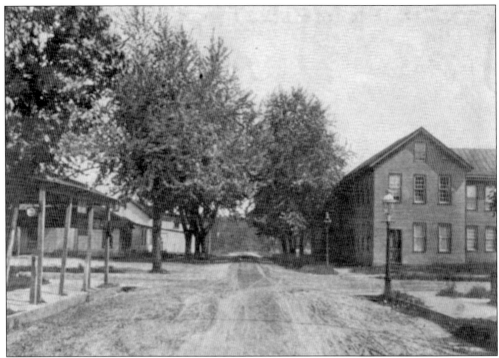

Looking south down Elmer Street, the canning factory (left) and Brooks Shoe Factory (right) were two industries that came to Elmer in the late 1800s. The shoe factory opened in 1886 to make ladies' shoes. It closed only a few years later in 1888, and the building burned in 1915. (JE.)

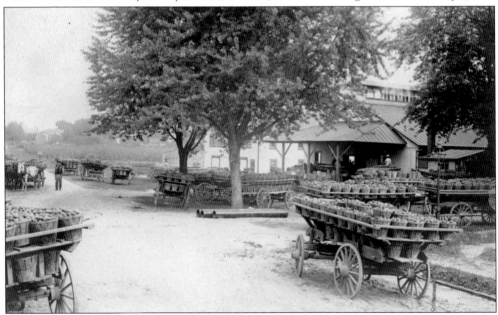

These wagonloads of tomatoes are lined up in front of Lucas F. Smith's cannery, which also canned pumpkins, pears, and other produce. After the cannery closed, the site was later used by Strang's Trucking. Some of the buildings are now used as storage for E.W. Bostwick's lumberyard and hardware store. (JE.)

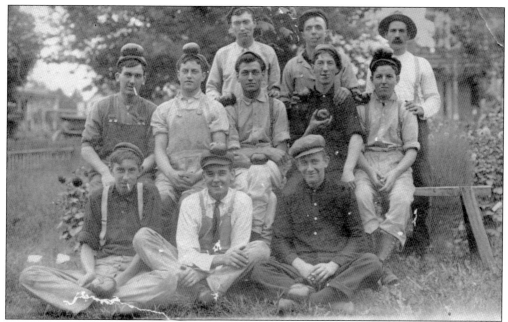

These cannery workers are showing off plump Jersey tomatoes. The tomatoes of South Jersey were prized by canning factories. Besides supplying nearby canneries, tomatoes would also be carted to the H.J. Heinz Company loading platform on Centerton Road or shipped to Camden for the Campbell Soup Company to produce tomato soup. (OG.)

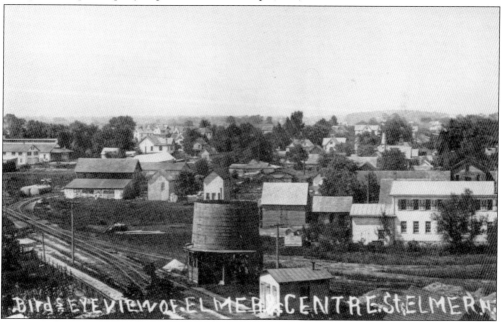

Facing west between Center and Broad Streets, one can see the cannery (far left), the water tower for replenishing steam engines (center), and a long white building (right), which was originally built in the 1890s as a shoe factory but was mostly used as a dress factory. Behind the dress factory are the rooftops of the Weietzell Creamery and Charles S. Cotting's spindle factory, later run by Ward and Vandergrift. (JE.)

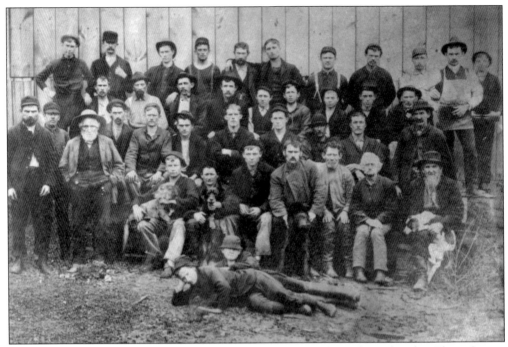

These glassworkers were employed at the lower glassworks along the railroad at Elmer Street. In 1885, the Elmer Glass Manufacturing Company began producing window glass, fruit jars, and insulators. Several glass companies operated at this factory, including Elmer Window Light Company; Getsinger Glass Company; Deijo, Goodwin and Company; Improved Gilchrist Jar Company; New Jersey Metal Company; Sterling Glass Company; Harloe Insulator Company; and Parker Brothers. The glassworks closed in 1907. (JE.)

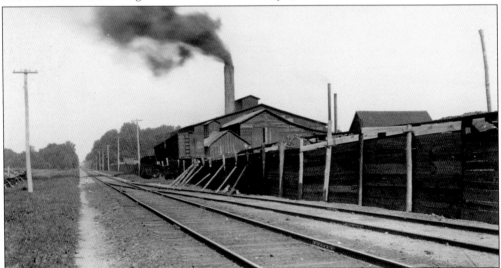

In 1896, Samuel M. Bassett established the upper glassworks along the railroad off Front Street. This glassworks produced bottles before selling in 1899 to Gilchrist Jar Company, which made fruit jars and lids. Novelty Glass Manufacturing Company bought it in 1901, making insulators, doorknobs, and battery jars. In 1904, R. Morris Davis produced insulators at the glassworks. The glassworks closed after Isaac L. Shoemaker bought it in 1907. (WPL.)

Looking west across Elmer Lake, the large white building was J.R. Edwards' Blacksmith and Carriage shop. Built by William Prowd in 1875, Edwards bought it in 1887 to be used for blacksmithing, wheelwrighting, and carriage-building. Edwards served as Elmer mayor in 1908–1910 and as leader of the Elmer Junior OUAM Band. Later, this was the George Smith auto dealership, which burned in the 1940s. (JE.)

Catholics began holding Mass in Elmer in 1892, beginning with the families of Frank Iles and Anthony Kentzinger. St. Ann's Catholic Church was built on Broad Street in 1894. In later years, the priest of St. Ann's also served as chaplain for the Mater Dei nursing facility, constructed in 1967. St. Ann's merged with two other churches in 2010, forming the Catholic Community of the Holy Spirit. (ET.)

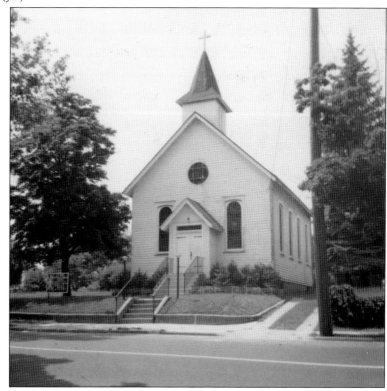

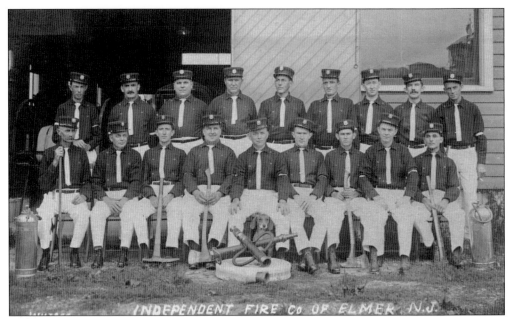

On January 9, 1901, a horrendous fire destroyed an entire block of South Main Street from State Street to Broad Street. Joseph W. Garrison's drugstore, the Baker Building, and the old Methodist parsonage (the home of John Ackley at that time) were completely destroyed. The following month, the Elmer Fire Department formed to prevent such a disaster from striking again. (JE.)

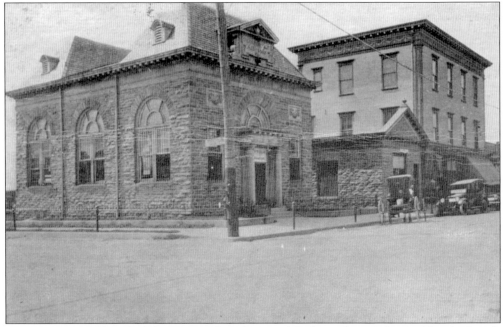

The Garrison Building (right) was erected on the site of the burned-out Baker Building by Joseph W. Garrison to be used as his drugstore downstairs and for Masonic lodge meetings upstairs. Beside the Garrison Building was the new post office (center); both buildings burned in 1960. First National Bank of Elmer (left) was established in 1903 with Samuel Preston Foster as president; the building was completed in 1904. (OG.)

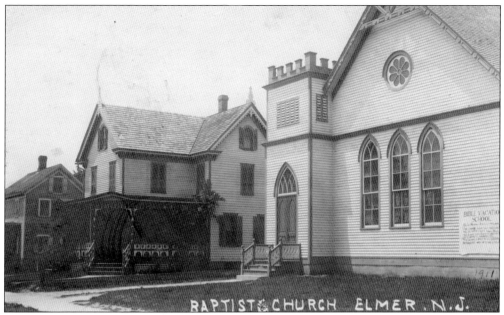

First Baptist Church of Elmer began meeting in 1903. The church was incorporated in 1905, and completed this building by 1906. Despite early financial troubles, the congregation was able to pay off its initial construction debts by 1919. First Baptist Church purchased a house on State Street to serve as the parsonage in 1929. Later, the house beside the church became the parsonage in 1949. (JE.)

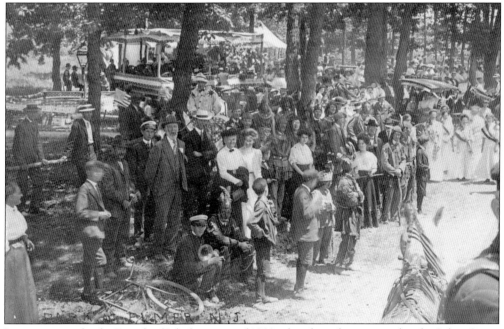

In preparation for the Fourth of July festivities of 1909, a bandstand was erected at the Salem Street Park for summer concerts of the Elmer Junior OUAM Band. An eighth-mile circular racetrack was also cleared and covered with gravel for holding footraces. Here, the Elmer community gathers at the Salem Street Park to watch the parade on July 5, 1909. (JE.)

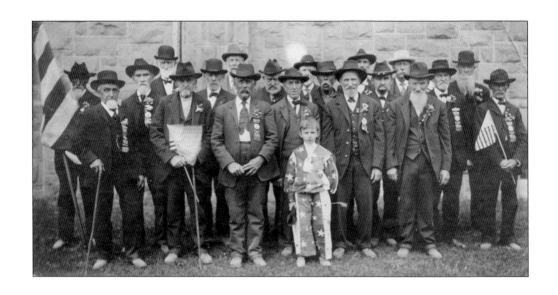

On Memorial Day 1909, the townspeople of Elmer honored their veterans, including these members of the Thomas A. Smythe Post of the Grand Army of the Republic (above). Standing behind their young mascot Harley Charles, these veterans are, from left to right, James P. Beckett, Lewis Wentz, John Shull, Robert Summerill, David B. Elwell, William Overs, Emerson Sherwood, John Bates, Henry S. Paulding, Charles Cole, George Smith, Robert Wallen, John Atkinson, William Campbell, Casper Pfeffer, Frank Dunham, George W. Green, Jacob Frazer, George Robinson, and Phillip Heileman. At another Memorial Day ceremony on May 30, 1940, Philip S. Reeves attended as the last surviving Civil War veteran of the community at age 98 (below). (Both ET.)

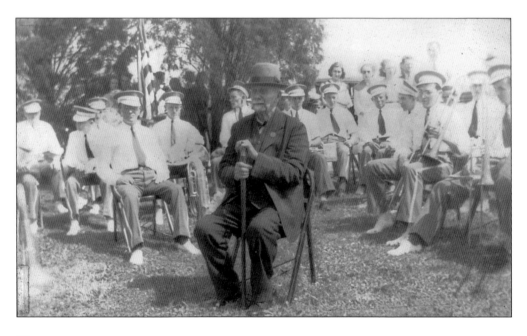

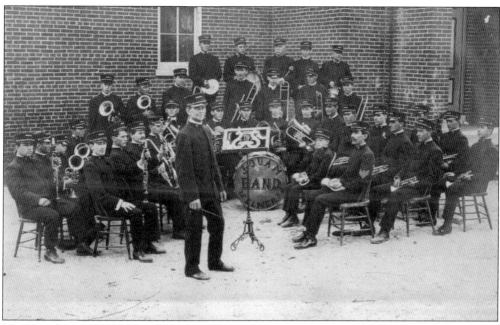

The Elmer Junior OUAM Band (above) is shown wearing new uniforms for the same 1909 Memorial Day festivities. The members include Maurice Hewitt, Ross Usinger, J.R. Edwards, E.W. Madara, Roscoe Goslin, Charles Bishop, Charles Nichols, Walter Fox, William Nichols, Mason Fox, Frank Stites, Leon Nelson, ? Matlack, Wilson Edwards, John Hannon, Arthur Wright, Fletcher Smith, Dayton Gibson, ? Matlack, William Madara, Edgar Charlesworth, ? Thompson, Alex VanLier, Ethan Wright, Charles Hughes, John Hughes, Irvine Wentzell, Jasper Wainwright, Herbert Dodge, Benjamin Timberman, Emerson DuBois, Charles DuBois, Aubrey Curry, William Ward, William Wright, Samuel Wright, and Samuel Day, the instructor holding the baton. The brass band marched down the street for the parade (below). (Both JE.)

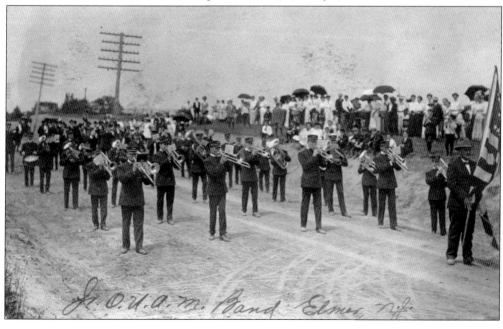

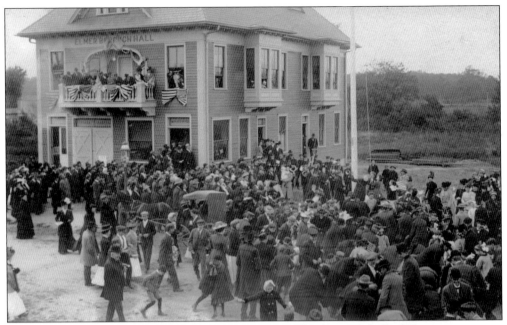

This borough hall of Elmer was constructed on Broad Street to serve as a municipal building, a prison, a library, and a fire station. In this photograph, the townspeople celebrate the dedication of the new building in 1909. After the old school on Main Street began to be used as the borough hall instead, this building was torn down in 1965. (JE.)

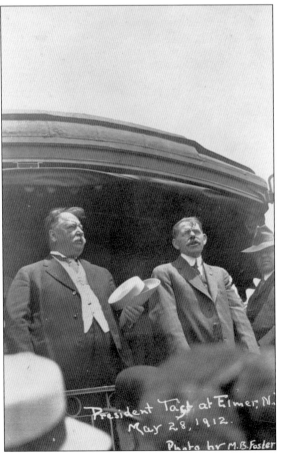

Pres. William H. Taft (left) rode into Elmer on the train on May 28, 1912, and spoke for 15 minutes to the crowd gathered at the train station. In this photograph by Mulford S. Foster, Sen. G.W.F. Gaunt is introducing Taft. Former president Theodore Roosevelt had also visited Elmer four days prior. (JE.)

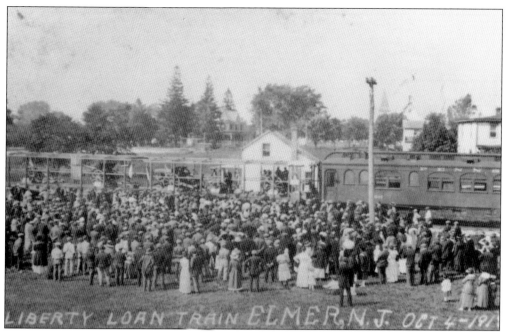

Once America joined World War I, many local residents joined the fight on battlefields overseas. One way citizens could support the war effort at home was by buying war bonds. This train came through Elmer on October 4, 1918, to sell Liberty Loan war bonds to support World War I. (JE.)

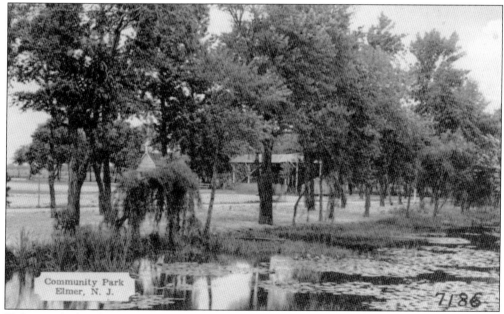

To honor the local veterans of World War I, Elmer citizens decided to build a park at the former site of the glassworks at the northern end of the lake. The whole community gathered together for a workday to clean up the land and build a grandstand for the new baseball fields. While this grandstand is no longer standing, the park is still used by Little League teams today. (JE.)

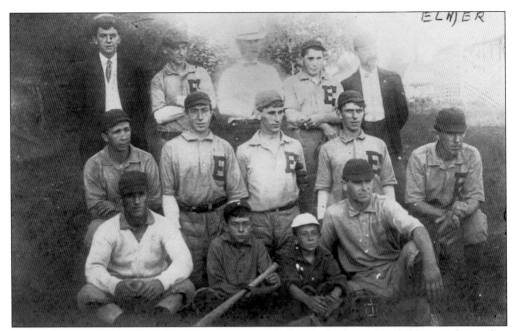

Before the baseball fields at the new community park were built, earlier fields were located at numerous sites all around Elmer. Pictured here is the Elmer Baseball Club of 1903. From left to right are (first row) Walter Newkirk, William Madara, Leon Bell, Frank Riley, and Lem Greenwood; (second row) Harry Warner, Sidney Burroughs, Hiley Strang, and William Brady; (third row) Herb Facemeyer, Warren Edwards, Russ Brady, and Clark Murphy. (JE.)

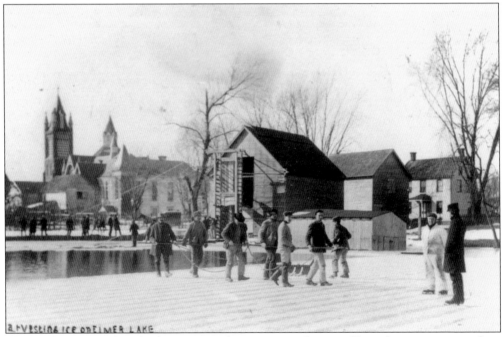

Elmer Lake contained a valued resource in the winter months—ice. Here, the community gathers on the lake to harvest the ice to be stored in the icehouse seen in the center of the photograph. In the distance is the steeple of the Elmer Methodist Church. (JE.)

80

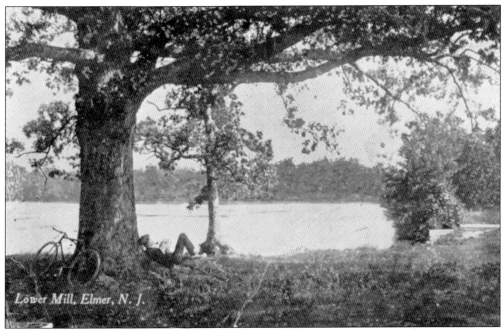

Lower Mill, Elmer, N. J.

South of Elmer was another millpond called Lower Mill, located at the end of Mill Road. Isaac Johnson owned a sawmill here in the early 1800s. In 1891, Robert Greenwood, who originally worked at Charles S. Cotting's spindle factory on Broad Street, erected a spindle factory near the sawmill. During World War I, Greenwood's spindle factory kept uniform factories supplied with spindles. After the factory closed, the Greenwood Lake property was sold in 1926 to Glassboro Normal School (now Rowan University) to be used as a camp for the students. It was renamed Camp Savitz after Dr. J.J. Savitz, the principal of Glassboro Normal School. These two photographs show visitors enjoying the lake before the camp was built. After the 1940 flood, the dam for Lower Mill was never rebuilt, and the lake passed out of existence. (Above, OG; Below, JE.)

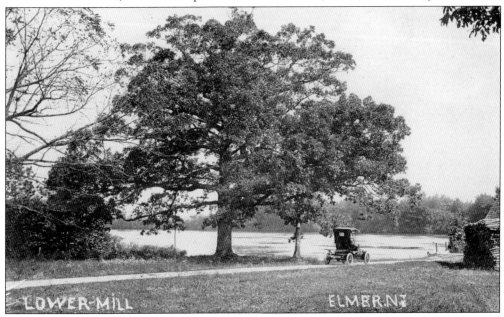

LOWER-MILL ELMER.NJ

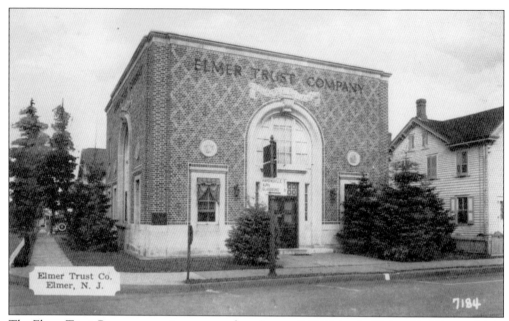

The Elmer Trust Company was incorporated on August 7, 1925, in the Haines Building on Main Street. The president was George Schalick of Centerton. This impressive building at Main and Front Streets was completed on August 28, 1926. It is still used as a bank, though its name has changed many times over the years. (ET.)

When the Elmer Theater (right) opened in 1927, it showed silent films accompanied by live organ music from a Wurlitzer organ. Isaac Sturr of Monroeville attended the opening show at the age of 92. The theater caught on fire in 1931, but reopened the following year. At that time, it began showing films with sound as well. (ET.)

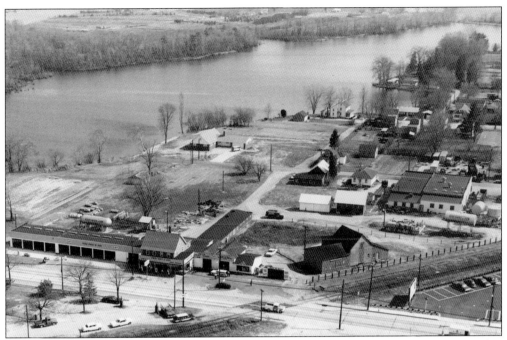

In 1920, George Franzen began selling tires at his shop on Route 40 (front left). His son-in-law Frederick Harz, who emigrated from Germany in 1929, bought the business in 1941. Frederick Harz Jr. next joined the tire business, followed by his son and grandsons. Harz also sold oil and propane; the oil tank (right) and propane tank (left) are visible in this 1968 photograph. (Courtesy of Frederick Harz Jr.)

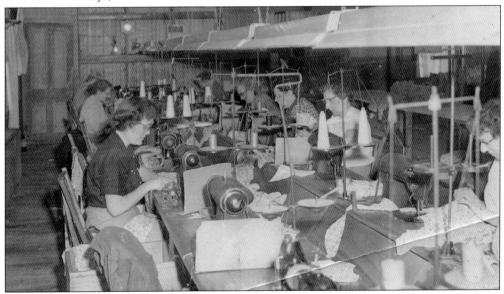

These ladies are stitching with sewing machines for the Elmer Dress Company in March 1958. The old dress factory building on Broad Street has housed many various sewing enterprises in the past century, producing wrappers, kimonos, children's clothing, and housedresses. The building was also temporarily used as a prison and a school in 1915. Other uses have included a dance hall, a car dealership, and a candle factory. (ET.)

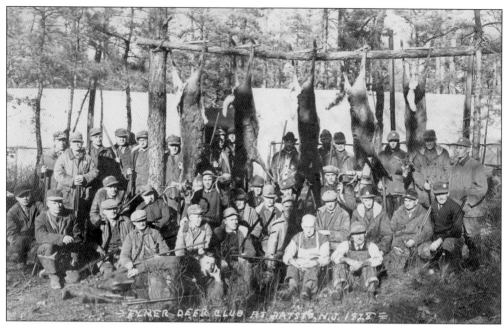

The Elmer Gun Club traveled to Batsto for a hunting trip in 1928. Here, members of the club are shown with the results of their hunt (above). The participants include, from left to right, (first row) unidentified; (second row) Louis Gantz, Ward Garwood, William Holdcraft, Clayton Wriggins, William Ward, unidentified, Charles Hitchner, Washburn Smith, and unidentified; (third row) unidentified, Clark Murphy, three unidentified, Wilford Houghton, Franklin Bishop, Jacob Riley, unidentified, John Ale, unidentified, John Shull, and Albert Coombs; (fourth row) Bud Kean, Benjamin Surran, Franklin Moore, Sidney Burroughs, Adelbert Moore, unidentified, John Harker, unidentified, Daniel Christy, Evan Prickett, C. Howard Ward, Rufus Harker, Isaac Riley, and Charles Bishop. Fifteen years later, the Elmer Gun Club was still an active group, as seen in this photograph from 1943 (below). (Both ET.)

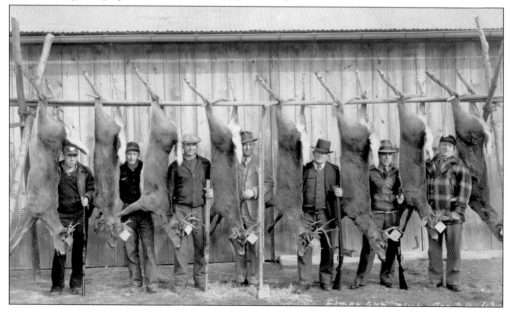

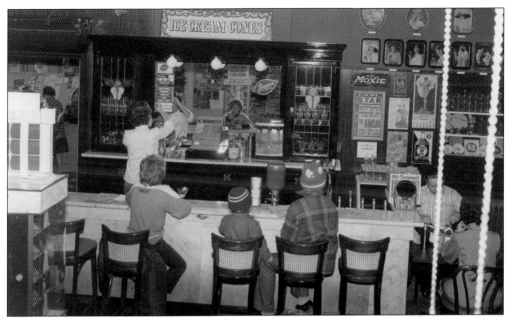

Inside the Five and Dime on South Main Street, a soda fountain provided refreshing drinks to customers young and old. This soda fountain was originally inside Scrubby's Pool Hall and Smoke Shop next door; it was moved into the Five and Dime when Scrubby's closed. This photograph was taken after the Five and Dime building was connected to the neighboring Johnson's Department Store. (ET.)

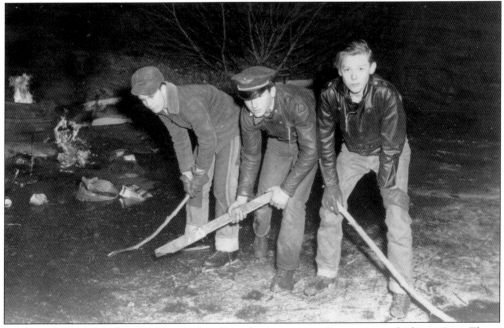

With makeshift wooden hockey sticks, these boys are enjoying a game of "shinny" on Elmer Lake one January evening in 1957. To ward off the cold, a rubber tire fire burns behind them. The skaters are, from left to right, Howard Riegel Jr., Charles McKishen, and Calvin Lee Thompson Jr. (ET.)

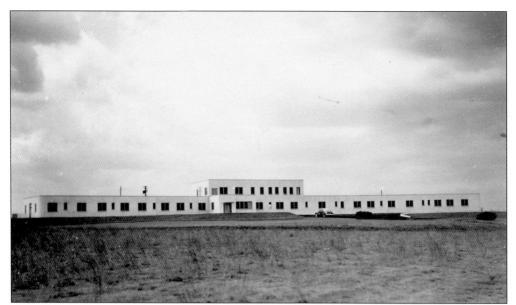

Paul E. Kramme of Monroeville was the founder of the Elmer Hospital. Shown here soon after it was built in 1950, it originally only had one floor; a second story was added in 1965. The hospital was further expanded and remodeled in the 1980s and 1990s, and it continues to serve Upper Pittsgrove, Elmer, and Pittsgrove residents today. (ET.)

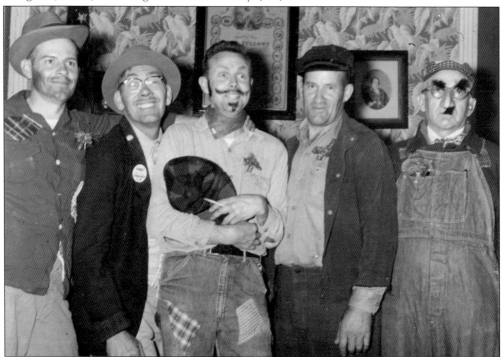

In October 1957, these men were installed as officers for the Elmer Odd Fellows Lodge, Zelo Lodge No. 49. They are, from left to right, Walter Hewitt, Harvey Toulson, Eugene Eisenbrey, Vincent Bozarth, and Isaiah Prickett. The Odd Fellows celebrated the event with a hobo dinner, with 100 people attending. (ET.)

Six

CENTERTON AND THE SURROUNDING SETTLEMENTS

One of the earliest settlements in Pittsgrove Township was Dayton's Bridge, later known as Centreville, and now Centerton. Just north of Centerton is the settlement of Olivet, previously called Broad Neck, where the Olivet Methodist Church was established in the late 1700s. The railroad once passed through the crossroads of Palatine, which lies west of Palatine Lake. Near the Upper Pittsgrove border is Greenville, also known as Pennytown. (ET.)

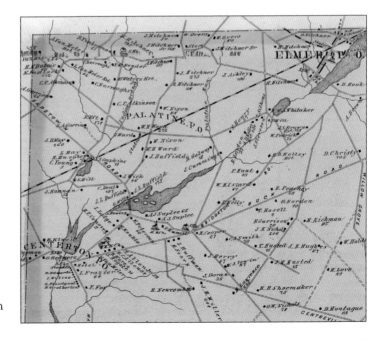

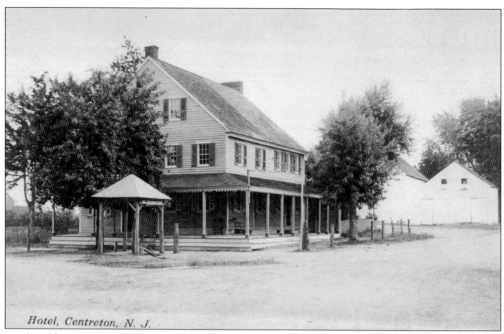

Hotel, Centreton, N. J.

As the old stagecoach routes passed through Pittsgrove Township, colonial travelers found shelter at taverns along the way. The landmark Centerton Inn has welcomed guests for almost 300 years, witnessing the town's name change from Dayton's Bridge to Centreville to Centerton. Built in 1731, this tavern served as an important stagecoach stop and meeting place during the Revolutionary War, and stories tell that the famous Marquis de la Fayette visited here while traveling during the war. Some early tavern keepers were Mr. Cox, Abraham Stull, Thomas Whitaker, Daniel Bowen, John W. Husted, Frederick Fritz, and Samuel F. Pancoast. Ye Olde Centreton Inn is still in business as a restaurant today. (Above, JE; below, CJ.)

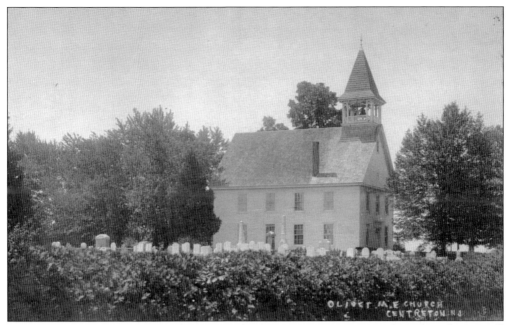

The Methodist Society of Olivet first met at the Centerton Inn, in private homes, and in a small chapel built about 1775. A log meetinghouse was built in 1788 on land donated by Adam Hannon. The first building was torn down in 1851, and this church was erected a bit west of the original location. With the old cemetery beside it, this remained the home of the Olivet Methodist Church until the construction of the current building on Centerton Road in 1964. A few years later, the old church was torn down, although the graveyard still remains. (Above, JE; below, ET.)

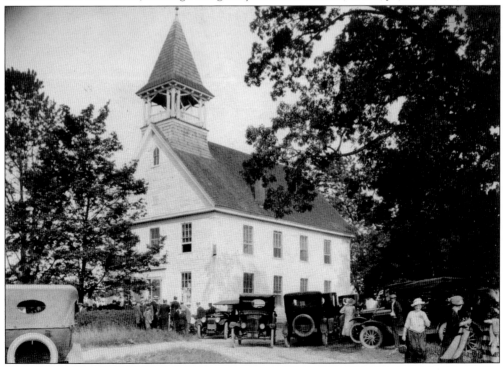

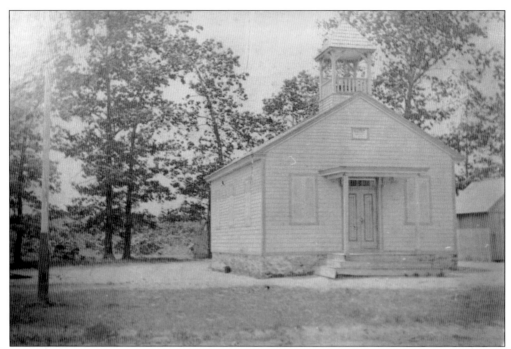

This original one-room Olivet School was constructed in 1867 and first called the Broad Neck School. It was used until 1922, when a new two-room schoolhouse was built. In the 1930s, Works Progress Administration workers remodeled the Olivet School. When all the students from the Greenville, Centerton, Good Hope, and Willow Grove schools transferred to Olivet in 1941, a large addition was constructed, followed by several other additions. (GEAHS.)

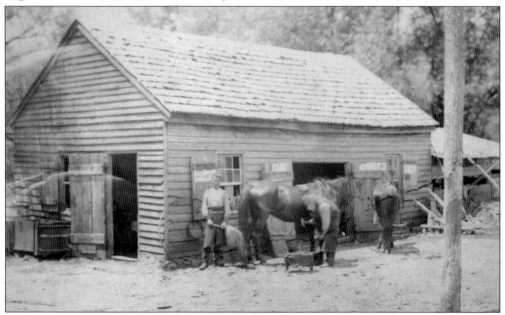

From the earliest colonial days, blacksmiths were present in each community of Upper Pittsgrove and Pittsgrove Townships. This c. 1900 blacksmith shop in Centerton may have been either near the general store or on Deerfield Road by the lake. (CJ.)

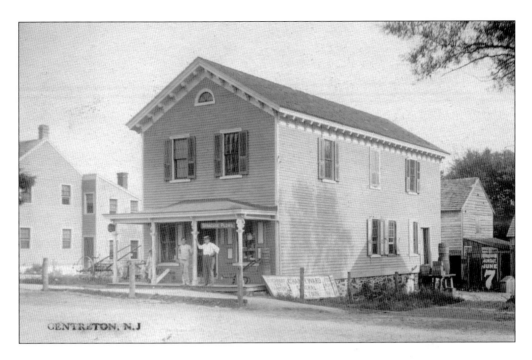

At the center of Centerton is the old country store. Storekeepers included Isaac Abbott, George Carpenter, Thomas Whitaker, James H. Trenchard, John Couch, Clark Iredell, and Richard R. Miller. In 1905, C. Harry Ward bought this store from Albert J. Fox, and it became known as Ward's Store for the next 50 years (above). His house stood to the left of the store. Ward also installed gasoline pumps by the 1950s (below). Later owners included Thomas McMahon, George Anderson, Norma Anderson, and Judy Omura. Now known as Anderson's Country Store, it still offers a small assortment of groceries and homemade sandwiches. (Both JE.)

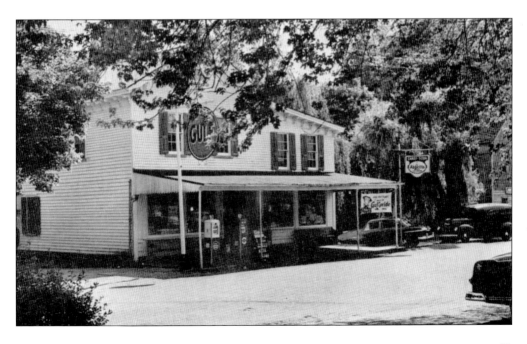

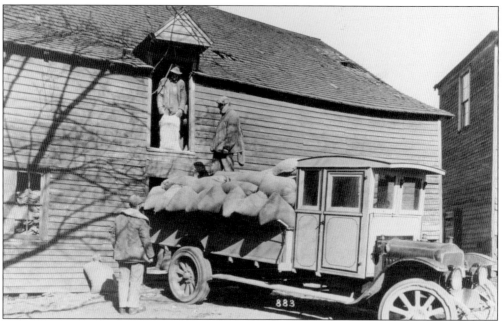

In 1891, George Schalick established a gristmill in Centerton and was later succeeded by his sons Arthur P. Schalick Sr. and Oakford Schalick. The Schalicks built a new mill along Dealtown Road in 1921, which burned in 1923 and was rebuilt. Here, the Schalicks' first truck is being loaded at the warehouse. Another fire in October 1943 destroyed the Schalicks' Mill and killed two firefighters. The Schalicks relocated to Elmer five years later. (CJ.)

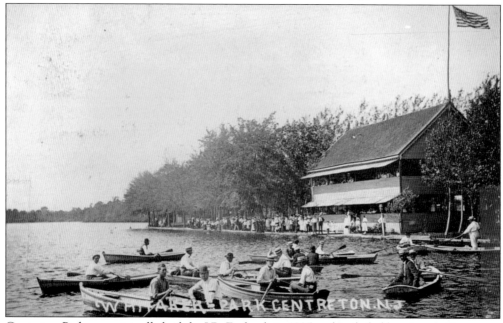

Centerton Park was originally built by J.R. Fitzhugh in 1895 and included boating on Centerton Lake, dancing in the pavilion, and spinning on the merry-go-round. Fitzhugh also owned a blacksmith shop, gristmill, and carriage factory, but he sold all his property to Lewis Whitaker in 1898. The park then became known as Whitaker's Park. (OG.)

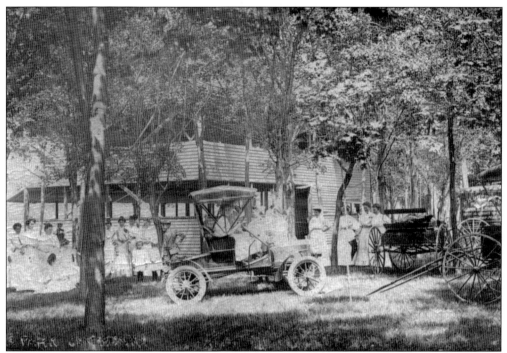

Hosts of visitors congregated at Centerton Park to attend the festivities, arriving both by carriage and by automobile, as seen in this early 1900s photograph (above). The pavilion offered refreshments, live music, and a large dance floor on the second floor. The merry-go-round was also enjoyed by all ages (below). Many years later, a two-story-high sliding board leading into the lake was a popular attraction for swimmers. Whitaker sold the park to Fred and Charlotte Lanusse. Their son Rene and his wife, Marion, were the last operators of the park before it was sold to investors, torn down, and turned into a site for upscale houses. (Above, JE; below, OG.)

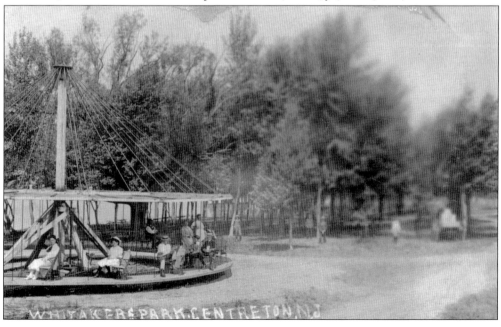

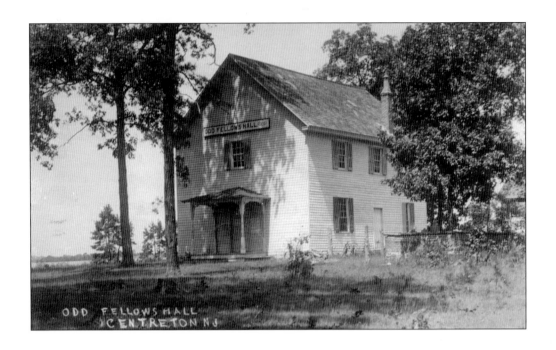

Originally erected as a Methodist church by Jeremiah Stull in the mid-1800s, this building on Dealtown Road then became the Odd Fellows Hall for the next hundred years (above). The Grotto Lodge No. 69, instituted in Centerton on December 30, 1847, was an active part of the community. This building has been torn down, but the Stull family graves from the early church can still be seen at the old site. When the old building used by the Odd Fellows could no longer be used, the present Odd Fellows hall was constructed on Elmer Road in the 1950s (below). It is now used as the Pittsgrove Township senior center. (Above, JE; below, ET.)

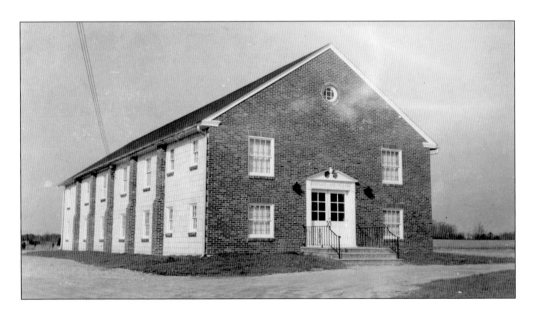

In this 1876 map, the Centerton School is drawn on Dealtown Road alongside the old Methodist church or Odd Fellows hall. Although an earlier schoolhouse was erected in 1840, this building was erected in 1872. The school educated eight grades in one room until 1939. At that time, the students were sent to Olivet School instead, and the schoolhouse was turned into apartments until it burned in the 1950s. (ET.)

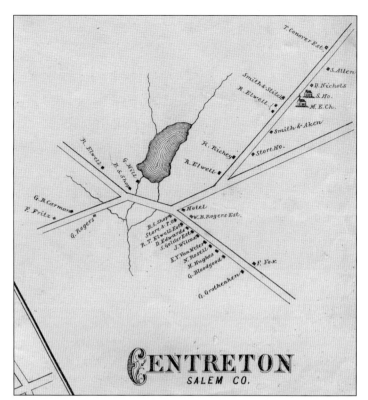

Ruble Burgess, Paul Sprouse, and John Wyatt organized the Centerton Free Will Baptist Church in 1963. The following year, this building was constructed on Dealtown Road. Both Ruble Burgess and Paul Sprouse became ordained as ministers and served as pastors of the church. Behind the church is a cemetery. (OG.)

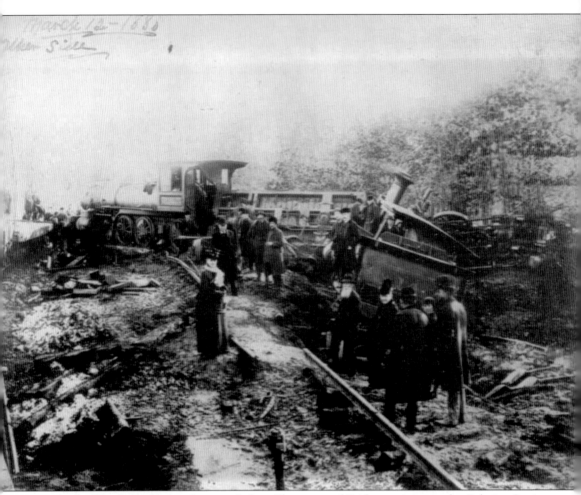

As the West Jersey Railroad ran south from Elmer toward Bridgeton, it stopped at Palatine Station on its way toward Husted Station at the Cumberland County border. The building used for Husted Station, which was originally located on Husted Station Road, was later moved around the corner onto Route 540, where it has been converted to a private residence. The blizzard of March 1888 caused a huge train wreck in Pittsgrove Township. While clearing snow off the railroad track from Glassboro to Bridgeton, a trio of engines and two coach cars derailed just south of Palatine Station. Although a number of townsmen had boarded in Elmer to gawk at the high snow banks, fortunately not a single person was killed in the wreck. (JE.)

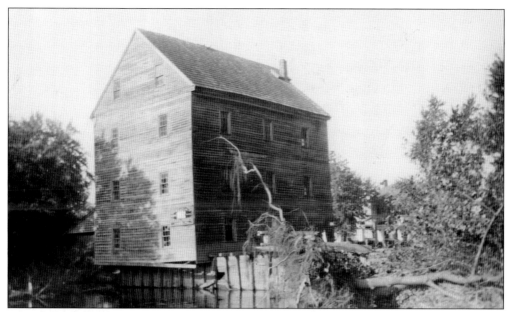

Along Olivet Road by Palatine Lake was a small community called Dealtown. An early mill was built here by Benjamin Haywood, which he used to grind husks. After Haywood's mill was abandoned, this gristmill was built around 1880 by James L. Duffield. Tragically, Duffield was killed when his overcoat got caught in the mill machinery. Charles Deal, son-in-law of Adam Hannon, was the next owner of the mill. (CJ.)

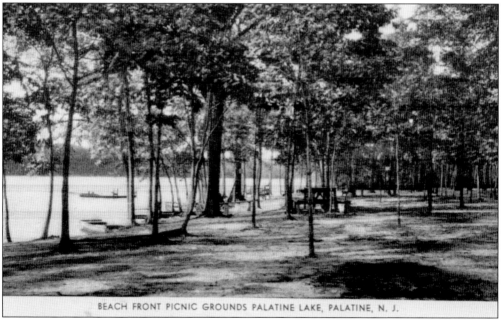

BEACH FRONT PICNIC GROUNDS PALATINE LAKE, PALATINE, N. J.

In the early 1930s, a man named Charles Gustafson bought Dealtown Pond and renamed it Palatine Lake, building a pavilion to provide a pleasant spot for picnickers and vacationers for many decades. In the late 1940s, Bernard Wegner bought the land, adding cabins and boating. Starting in the 1970s, many spacious homes have been constructed around this lake in the new Palatine Lake Village neighborhood. (OG.)

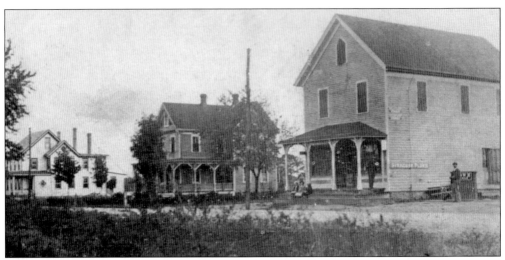

William H. Ward moved to the Palatine area in the 1850s, purchasing 250 acres. He was an advocate of the railroad coming in 1861, which brought commerce and opportunity to the sparsely settled community. The railroad station was originally named Ward's Station, but at his protest, the name became Palatine instead. Ward also served as the postmaster. His sons were active members of the Pittsgrove community, including C. Harry Ward of Centerton and John C. Ward who served as New Jersey state senator in the 1890s. After Ward's sons James C. Ward and Frank G. Ward Sr. bought out Charles Keen's small store in 1891, they built the store on the right across the street (above). The second floor of the building was used by the Redman's lodge. The Palatine store also provided gas to early motorists (below). (Above, JE; below, CJ.)

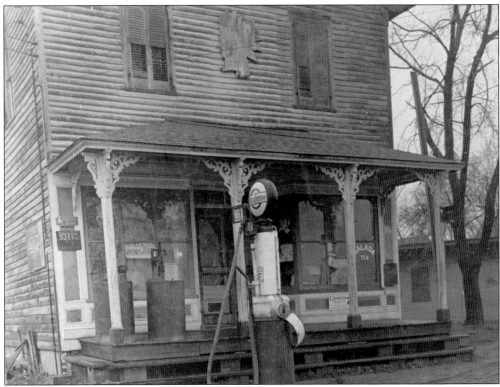

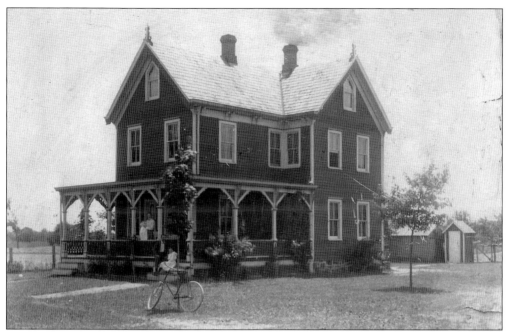

Frank G. Ward Sr. built this house alongside the Palatine store. The photograph, taken in 1899, shows the Ward family at home. From left to right are infant Helen Imogene Ward, Mary Ann Biggs Ward, Frank G. Ward Sr., and daughter Mary Anna Ward. (Courtesy of Robert Widdifield.)

Frank G. Ward Sr., proprietor of the store, stands in the back center of this photograph showing the inside of the general store. His son Frank G. Ward Jr. remodeled the store in 1948, renaming it Palatine Country Store. The store was eventually converted into a residence, still located at the crossroads. (CJ.)

Jacob and Magdalena Hitchner came to the Greenville (also known as Pennytown) area of western Pittsgrove Township in 1754. Their descendants were so numerous that a third name for Greenville was Hitchnertown. Matthias Hitchner raised 12 children in a small two-room log house at the intersection of Burlington Road and Palatine Road. His son Adam Hitchner built this house on the same property in 1886. (OG.)

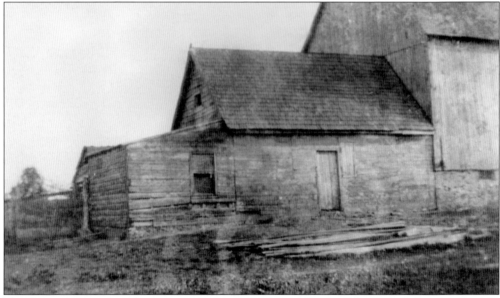

The Garrisons were another important family in Greenville. In 1761, Samuel Garrison bought 200 acres of land along Burlington Road, which originally ran a bit east of the current roadway. This small one-room house was where he and his wife, Lydia, raised their 10 children. Shown here after it was no longer used as a house, it was attached to a barn in 1897 and torn down in 1922. (OG.)

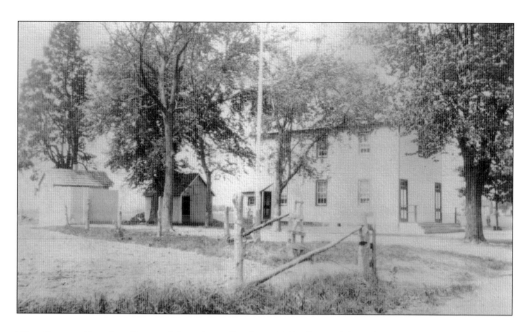

The Greenville schoolhouse (above) was built in 1869 along old Burlington Road at Greenville Road. It had two rooms, with the upstairs used for the upper grades and the downstairs used for the lower grades. This schoolhouse was also used for a Methodist Sunday school. These students from 1911 (below) include, from left to right, (first row) four unidentified, John Oakford Eft Sr., Harold Shimp, Ruth Hitchner, Milton Hitchner, Russell Timberman, and unidentified. The girl in the center in the light-colored dress is Aletha Hitchner, but the rest of the children are unidentified. This school was used until 1941, when the students transferred to the Olivet School instead, as did the Sunday school. (Above, GEAHS; below, JE.)

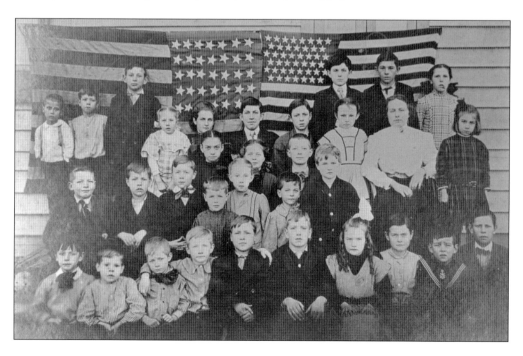

The students of Pittsgrove Township for many decades commuted to Bridgeton or Vineland for high school. In the 1960s under the leadership of Arthur P. Schalick Sr., the Pittsgrove Township School Board and the Elmer Board of Education agreed to pursue building a new high school in Centerton. The Arthur P. Schalick High School opened in September 1976 for seventh- through twelfth-grade students. The high school band (below) is shown playing for a game at Schalick High School on September 24, 1977. The first band director, Forest Eichmann, is standing at the fence (front center). Later, the middle school was built in 1989 on Almond Road, and the seventh and eighth grades transferred to there. These schools serve all of Pittsgrove Township. (Both CJ.)

Seven

Union Grove and the Parvins' Park

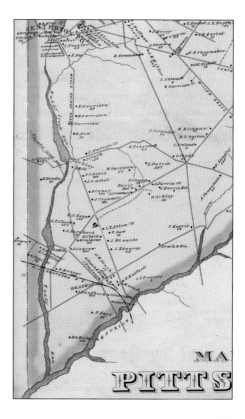

The land around Parvin's Lake once belonged to John Estaugh, husband of Elizabeth Haddon, the founder of Haddonfield. Later, Lemuel Parvin bought a tract of Lower Neck land in 1796, and the community of Union Grove formed near the millpond, populated by Parvins, Ackleys, and Creamers. Changes came to the small community in the 1930s with the construction of Parvin State Park, which now includes much of this land. (ET.)

Around 1783, a dam was built along Muddy Run, forming a lake and waterpower for a mill in the area that was then called Lower Neck. Lemuel Parvin and his son Charles bought the mill property in 1796. Charles married Anna Margaret Hires, the granddaughter of Jacob Hitchner of Greenville. The Parvins had one son, Lemuel Parvin, before Charles died in 1803. Anna Margaret remarried Hosea Nichols and had three children. Then, after Nichols also died, she married her third husband, Jacob Creamer, in 1810, birthing nine more children. Creamer operated the mill, which was called Creamer's Mill, until his death in 1835. He left the mill to his stepson Lemuel Parvin, grandson of the original owner. In 1847, Parvin replaced the old mill with a new one (above and below). (Both JE.)

Boat Landing, Muddy Run, Vineland, N. J.

During the 1820s, these Lower Neck residents began meeting for worship at the Ackley schoolhouse, named after teacher and preacher Uriah Ackley. When a new schoolhouse was built in 1835, it served both for education and church meetings. It was not until 1851 that the Union Grove Methodist Church was officially organized. This building was constructed in 1869 on land donated by the Creamers and the Parvins. (MACS.)

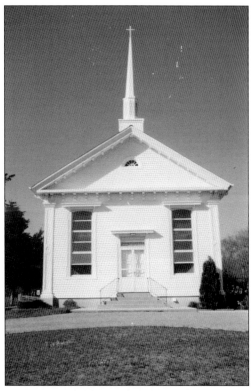

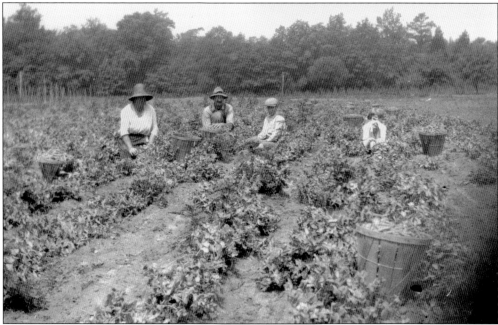

One of the descendants of the original Creamers of Union Grove was Warren Creamer, who had a farm on Alvine Road where he raised various vegetables. Here, Creamer picks crops with his family in 1925. From left to right are his wife, Ella Baker Creamer; Warren Creamer; and their children John Creamer and Edith Creamer. (CJ.)

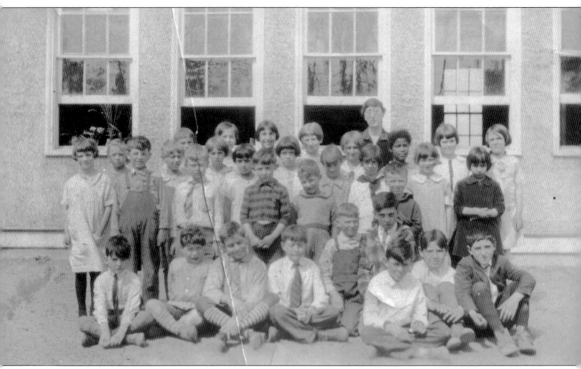

The Methodists used the first schoolhouses of Lower Neck, later called Union Grove, for church services. This Union Grove School was located on Almond Road just east of Alvine Road. It had two rooms, with four grades in each room. In the late 1800s, this school also educated children from Norma and Alliance until new schools could be built for those growing communities. The teacher in this photograph from the late 1920s is Bessie Astle. Although this building later burned, the pump can still be seen at the old site on Almond Road. (CJ.)

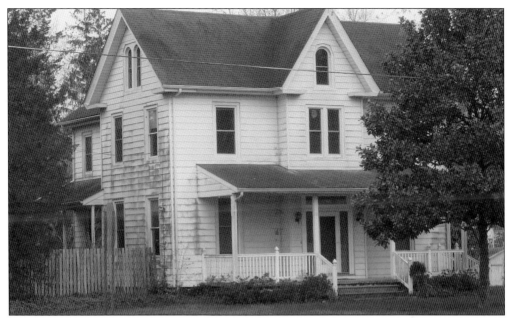

After Coombs Ackley, one of Rev. Uriah Ackley's 14 children, married Lemuel Parvin's daughter Jane in 1849, he took over the mill from his father-in-law. Ackley built this house on the southeast corner of Parvin Mill Road and Almond Road. In the late 1800s, Ackley sold the mill property to John Smith, who made it a recreation park. It soon became a whirlwind of early-20th-century experiences. (BBE.)

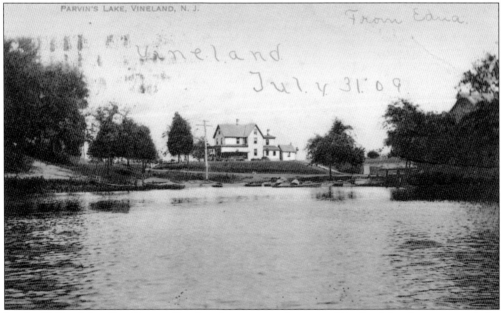

In the 1920s, John Smith's son Frank, who was a cashier at a Vineland bank, mortgaged the property for $39,000 in the bank's name to play the stock market. When the stock market crashed in 1929, Smith's embezzlement was discovered, and he was imprisoned. Stockholders of the failed bank convinced the state government to purchase 1,000 acres of land, including the lake, for a state park in 1931. (JE.)

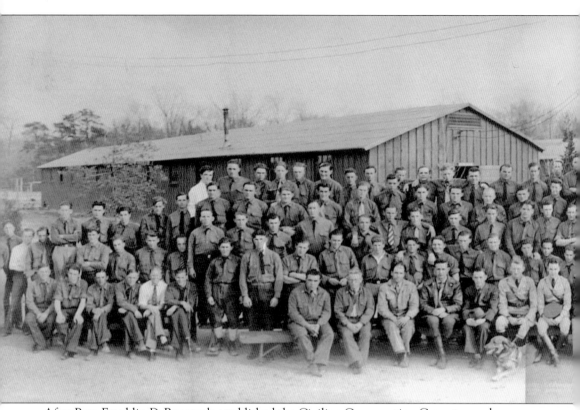

After Pres. Franklin D. Roosevelt established the Civilian Conservation Corps to employ young men with government projects, Company No. 1225 was formed on October 30, 1933, to work on the Parvin State Park project. These Civilian Conservation Corps workers lived in a camp located three-fourths of a mile west of the main beach, which can be seen behind the workers in

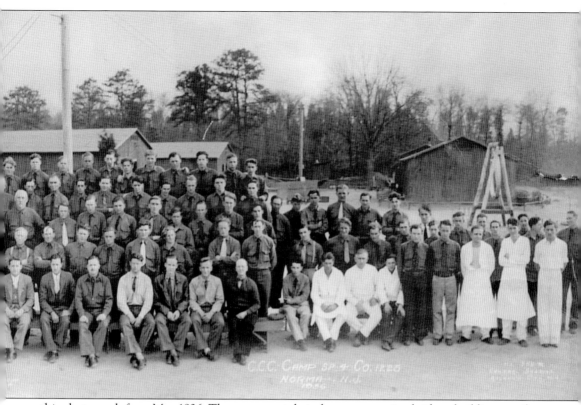

this photograph from May 1936. The men spent their days constructing bridges, buildings, trails, pavilions, Thundergust Lake, and many other aspects of the park. In 1937, Company No. 2227V took over the work at Parvin State Park, which included rebuilding the dam after the flood of 1940. The Civilian Conservation Corps camp was closed on May 15, 1942. (MACS.)

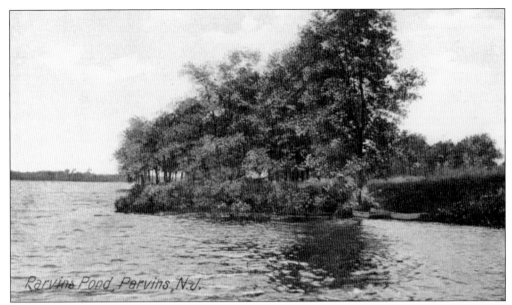

Today, Parvin State Park is a center for outdoor recreation. However, during World War II, the old camp barracks temporarily housed displaced Japanese Americans coming to work for Seabrook Farms in 1943. The camp was then used as a prison for German POWs in 1944. Later, it was a refugee camp for Kalmyks, who were Russian Mongolians fleeing from Eastern Europe in 1952. Finally, the old barracks were torn down. (JE.)

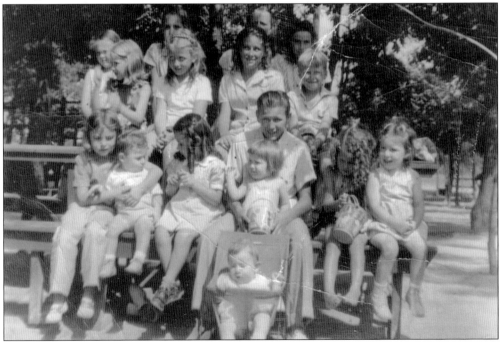

In this photograph, families from the Union Grove community gather at Parvin State Park for a relaxing afternoon. The park provides picnic spots, a sandy beach for swimmers, boating on the lakes, nature trails through the pine and deciduous forests, camping spots and cabins, and endless entertainment for visitors today. (CJ.)

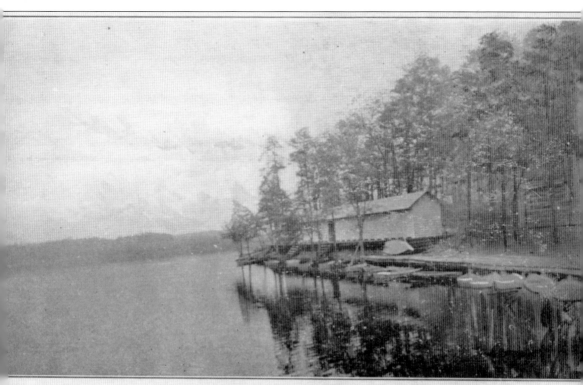

778 VIEW OF RAINBOW LAKE, Near Norma, N. J.

In the southeast corner of Pittsgrove Township is Rainbow Lake. Once a popular vacation spot in the early 20th century, quite a few vacationers would ride the train from Philadelphia and other cities to stay at one of the resorts near the lake. The Rainbow Lake Hotel and Richards Farm and Catering were two resorts on Landis Avenue that provided housing for the visitors. Another popular entertainment on the lakefront was the Rainbow Skating Rink. It provided space for roller-skating, as well as a dance hall. Once the resort became less popular by the mid-20th century, the skating rink fell into disrepair. It burned down around 1950. (JE.)

The Friendly Neighbor Club was a social club for the women of the Union Grove community, primarily made up of members of the Union Grove Methodist Church. These homemakers would meet at a different home each month for an evening of fellowship with other ladies, fun with word games, and homemade refreshments. One member of the club was designated the Sunshine Person, who was responsible for sending out get-well cards and birthday cards. Once a year, the group would take an all-day bus trip, including one trip to the 1964–1965 New York World's Fair. This gathering of the Friendly Neighbor Club during the 1948–1949 Christmas holidays includes, from left to right, (first row) Alice Creamer, Rhoda Robinson, Pauline Parvin, Helen Creamer, unidentified, and Wilma Creamer; (second row) Emma Creamer, unidentified, ? Lorenz, ? Creamer, Bessie Astle, and unidentified; (third row) unidentified, ? Spickenreuther, Edith Camp, Mabel Granger, unidentified, Violet Schade, Alice Shaper, Thelma Parvin, ? Mills, Grace Creamer, and Lillian Harris. (CJ.)

Eight

WILLOW GROVE AND NORMA'S NORTHERN NEIGHBORS

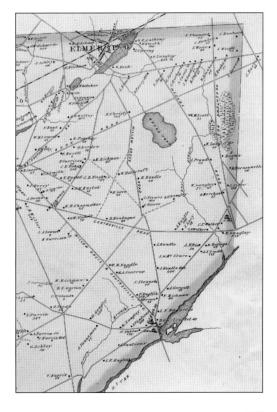

In the 1800s, the only landmarks between Elmer and the small community of Willow Grove were a cedar swamp and Broad Pond. Recently, a few trailer parks, nursing homes, and convenience stores have sprung up along Route 40. However, on the eastern border of Pittsgrove Township, the population expanded in the 1880s when displaced Russian Jews founded the communities of Alliance and Brotmanville between Norma and Willow Grove. (ET.)

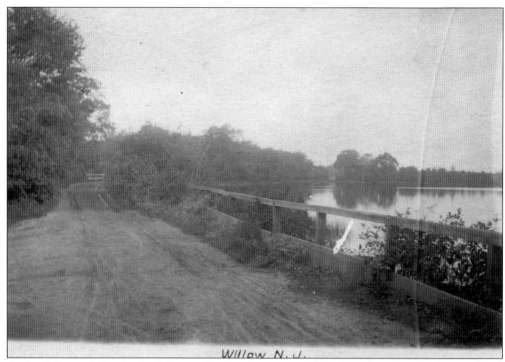

Willow N. J.

At the Salem and Cumberland County border, the streams of Scotland Run from Malaga and Still Run from Iona converge to form the Maurice River. Around 1789, Samuel Darling built the first dam here, forming the lake at what was originally called Fork Bridge or Fork Mills (above). The area was called Willow Grove by 1845 when Thomas Woodrow sold the gristmills and a half-share of the sawmill to John W. Richman, James G. Ford, and Thomas Dare Sr. In 1857, Dare bought a plot of land on the eastern shore of the lake, where he built a frame house. Dare kept a store in his house, served as postmaster in 1870, and ran the gristmill. In this view of Willow Grove looking east (below), the house on the left was probably Dare's residence. (Both JE.)

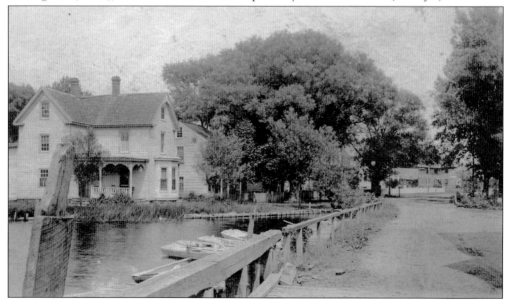

114

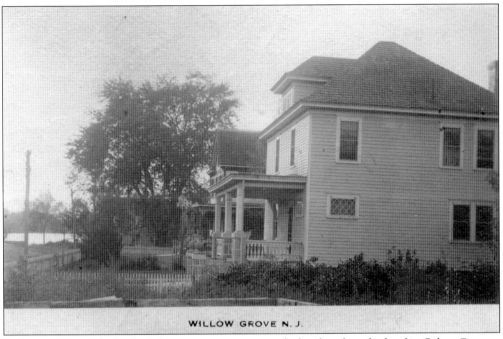

WILLOW GROVE N. J.

Willow Grove is split by the lake into two counties, with the church and school in Salem County, but most of the village center in Cumberland County. These two houses on the east side of the lake belonged to Sanford C. Fox (front) and to miller Thomas C. Fox (rear). Farther west toward the lake stood the two houses pictured on the previous page, which are no longer standing. (JE.)

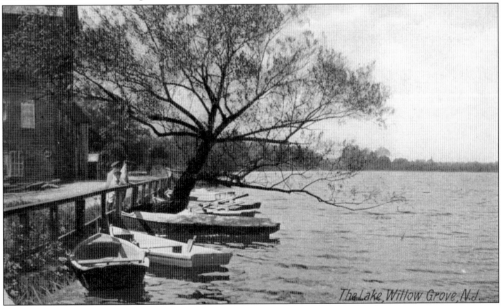

The Lake, Willow Grove, N.J.

Leaving his brother Charles at the Daretown mill, Thomas C. Fox moved to Willow Grove in 1888 and bought this gristmill (left) from Lee and George Langley. During World War I, the mill was expanded into a four-story building, producing 1,000 barrels of flour a month. In 1942, the mill stopped operation because of the shortage of labor during World War II. The mill burned in 1949. (OG.)

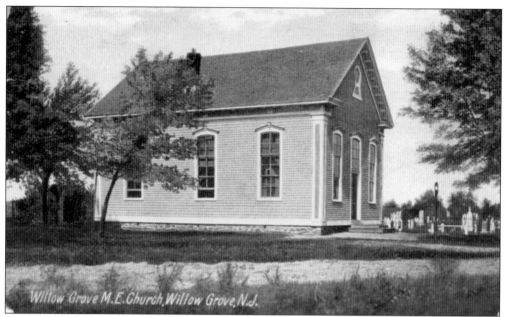

Willow Grove M.E.Church,Willow Grove,N.J.

The Methodists of Fork Mills, later Willow Grove, first met in a log meetinghouse east of the lake. Revs. Richard Swain and Asa Smith were early preachers in 1803. They next met in a schoolhouse built in 1823. Finally, the Willow Grove Methodist Church was built in 1855 in Pittsgrove Township west of the lake. After it burned in April 1880, this structure was erected to replace it. (OG.)

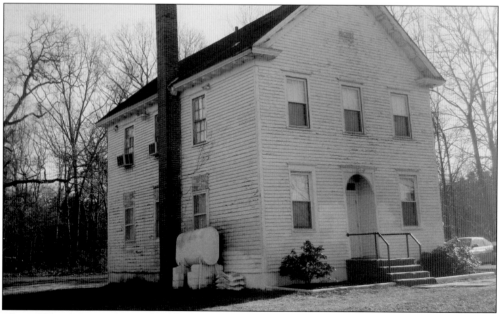

The Willow Grove School was built near the church in 1883, replacing an earlier school. During the 1920s, it closed briefly, and students commuted to the Union Grove School by wagon until it reopened in 1928. When the school closed in 1941, it was sold to the Wegner family. It was later sold to New Macedonia Free Will Baptist Church and is currently used by Faith Temple Assembly. (BBE.)

Heading west along Route 40, the Mater Dei Nursing Facility is located halfway between Porchtown and Elmer. Shown here shortly after construction, it was started in 1967 by a congregation of nuns known as the Marianite Sisters of the Holy Cross. The first administrator was Sr. Cecelia Mahoney, and the priest of St. Ann's Catholic Church served as chaplain. In 2012, the Diocese of Camden closed the facility. (ET.)

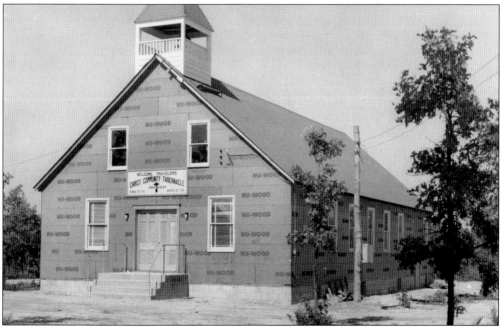

Down the road from Mater Dei, Christ Community Tabernacle formed in 1953 under Rev. William Green, meeting in the old Elmer Theater at first. Then, in 1955, this building was constructed along Route 40. Before they had pews, they used the old theater seats. Later, an addition was built in 1986. The current pastor is Rev. Joseph Zearfaus Jr. (ET.)

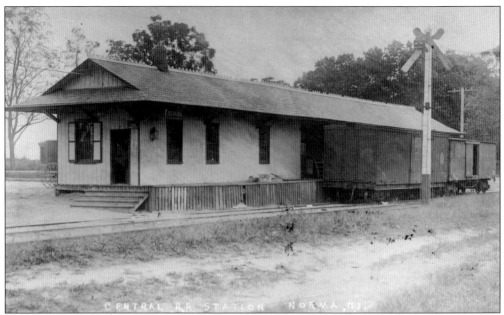

South of Willow Grove along the eastern edge of Pittsgrove Township is the town of Norma, once called Bradway's Station. When the New Jersey Southern Railroad was built in 1870, connecting New York City to Vineland, the train briefly passed through the southern tip of Pittsgrove Township. Bradway's Station (above) was named for a nearby family; the town was later renamed Norma. Another early family was the Leaches, who ran a sawmill and owned a large portion of the land on this map (below). The Leach brothers sold much of this land to the Alliance Land Trust, as the Alliance Colony sought to establish an agricultural community for Jews fleeing the pogroms of Russia. This settlement grew to cover the whole region north of Norma, forming the towns of Alliance and Brotmanville along Gershal Avenue. (Both ET.)

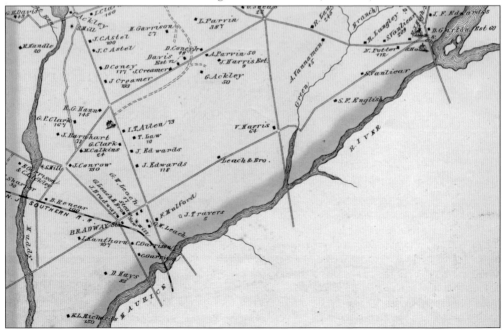

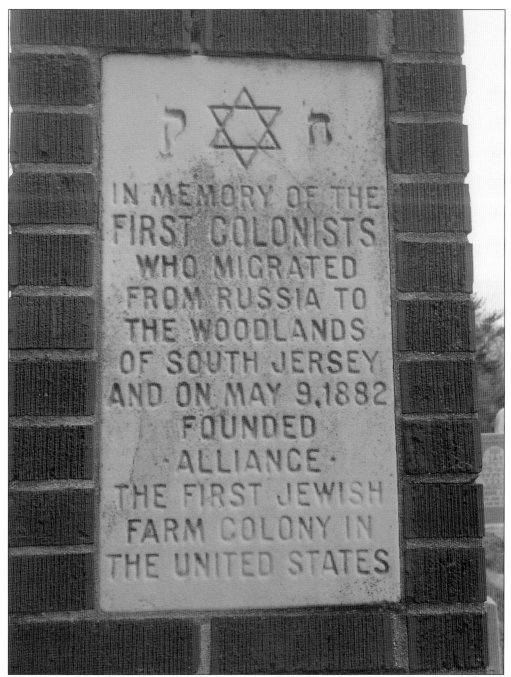

IN MEMORY OF THE
FIRST COLONISTS
WHO MIGRATED
FROM RUSSIA TO
THE WOODLANDS
OF SOUTH JERSEY
AND ON MAY 9,1882
FOUNDED
· ALLIANCE ·
THE FIRST JEWISH
FARM COLONY IN
THE UNITED STATES

In 1882, Moses Bayuk and 43 Jewish families arrived at Bradway's Station, forming the Alliance Colony, as commemorated on this plaque. As the new arrivals had no shelter, local politicians arranged for 1,200 Army tents to be loaned to the settlers until temporary barracks were erected. The Leaches cleared the timber from the settlers' land and built two-room houses on each family's 15-acre lot. The larger brick house that belonged to Bayuk is still standing in disrepair near the Jewish cemetery. Bayuk had been a lawyer in Russia, and after settling in New Jersey, he served as a justice of the peace for 40 years, as well as farming and authoring several Hebrew books. (BBE.)

The first Alliance Colony synagogue was Eben Ha'Ezer (Rock of Salvation), erected in 1888 on Isaacs Avenue, with the congregation called Emmanu'El. The basement served as Alliance Hall for social events until 1940, when it was torn down. The second synagogue Scharis Israel (Remnant of Israel) was built in 1889, and the congregation was called Tifereth Israel (Splendor of Israel). Shown here in 1928, this synagogue still stands on Gershal Avenue. Although the children of Alliance studied Hebrew through the synagogues, they originally walked to the Union Grove School for their primary education. Later, Alliance School was built beside the Eben Ha-Ezer Synagogue, and Norma School was built on Gershal Avenue near Almond Road. Near Norma School, benefactor Maurice Fels had a manual training building constructed for educating young men and a domestic science building for young women. He also established Allivine Farms under Raymond L. Lipman for agricultural training and experimental farming, as well as a cannery near the railroad for the Alliance farmers' produce. (Courtesy of the Jewish Federation of Cumberland, Gloucester, and Salem Counties.)

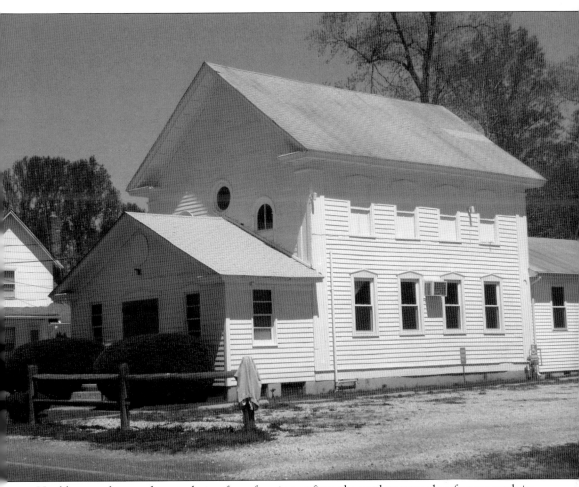

Unable to make an adequate living from farming at first, the settlers turned to factory work in the winter. The old barracks, nicknamed Castle Garden, served as a cigar factory, and later as the Eskin clothing factory, after which the community of Eskinville was named. A man from New York named Abraham Brotman built a large clothing factory on Gershal Avenue near Garden Road, and the community of Brotmanville formed around it, including a school in Brotmanville. This B'nai Moshe Anshei Estreich synagogue in Brotmanville was constructed in 1901. It was also used as a community center. Later, it was turned into an African American church, Mount Moriah Missionary Baptist Church. Southern migrant workers who came to work at Seabrook Farms founded Mount Moriah. They bought the building in 1981. (BBE.)

The B'nai Jacob synagogue in Norma on Almond Road was built around 1920 by the second wave of immigrants, mostly German Jews. This building is still standing today, but it is no longer in use, as most of the original Jewish settlers moved away from the region by the 1940s. (MACS.)

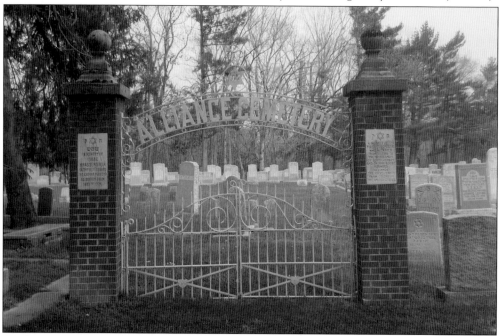

At this extensive Jewish cemetery in Alliance, a chapel houses the Alliance Heritage Museum, maintained by the Alliance Colony Foundation. The building was originally used by the *chevra kadisha*, the organization in charge of burials. It now contains the furniture from the Brotmanville synagogue, which was removed when the building was sold. (BBE.)

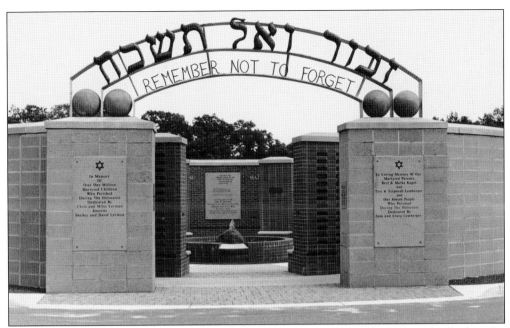

At the cemetery, this memorial was erected in 1994 to remember the millions who died in the Holocaust. Even though the Jewish settlers no longer live in Alliance, Brotmanville, and Norma, the cemetery and the remaining synagogues stand as testimonies to the region's fascinating history. Anniversary celebrations in 1932, 1982, and 2007 reunited descendants of the original Alliance Colony settlers, and much work has been done to preserve their stories. (CJ.)

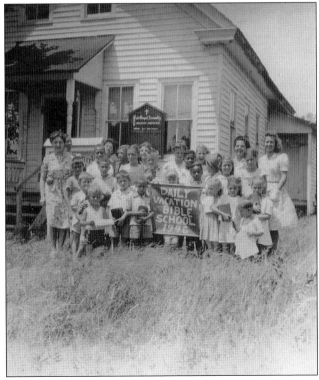

Originally a button factory, this building was used as a church by 1946. First called Full Gospel Assembly, it was later renamed the Community Church of Norma. The addition was built in 1970; by then, the church was also known as the Christian Welfare Church. The name changed to Norma Independent Free Will Baptist Church around 1985; it is now simply Norma Baptist Church. (Courtesy of Norma Baptist Church.)

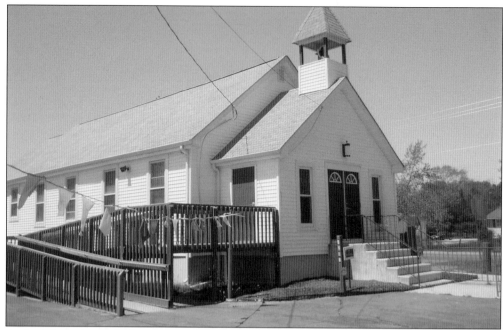

As Jewish settlers left Norma, Alliance, and Brotmanville, African American and Hispanic families moved into the region, bringing additional diversity to this area of Pittsgrove Township. Friendship Baptist Church (above) is an African American church located in Brotmanville at Gershal Avenue and Garden Road. During the 1950s, Mennonites who were conscientious objectors came to South Jersey to do two years of voluntary service at nearby Vineland medical facilities as an alternative to registering for the draft. These Mennonites formed the Norma Mennonite Church on January 13, 1957, under founding pastor Rev. John Miller, who served the congregation until his death in 1984. The congregation originally met in the building of the Norma Baptist Church. As Vacation Bible Schools reached out to the surrounding community, many ethnically diverse families joined the congregation. The current building (below) was erected in 1968 on Almond Road. (Both BBE.)

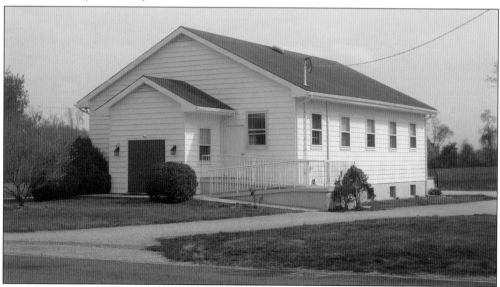

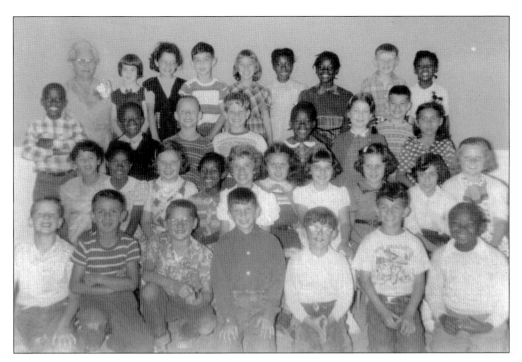

In 1953, a new school was built in Norma for students from Alliance, Brotmanville, Union Grove, and Norma. This photograph shows the second-grade class of Norma around 1955 (above). Many of the students in the Norma School were minorities by the 1960s. In an attempt to further integrate the schools in the early 1970s, all of the fourth- and fifth-grade students in the township were sent to the Norma School while the rest of the students attended the Olivet School. Later, the Norma School became Pittsgrove Township's preschool and kindergarten. These kindergarten students (below) are getting off the bus at Norma School in October 1976, ready to step into a future that will hopefully hold both change for the better and an appreciation for the past. (Both CJ.)

BIBLIOGRAPHY

"Century Old School Takes Another Ride." *Elmer Times.* Aug. 10, 1950.

Charlesworth, Edgar. "Blacksmiths of Elmer." *Elmer Times.* Sept. 5, 1940.

———. "Storekeepers in Elmer and the Immediate Vicinity." *Elmer Times.* July 16, 1942.

Children in the Elementary Schools in Salem County. *A Story of Salem County.* 1937–1938.

Cushing, Thomas, and Charles E. Sheppard. *History of the Counties of Gloucester, Salem, and Cumberland, New Jersey, with Biographical Sketches of Their Prominent Citizens.* Philadelphia: Everts and Peck, 1883.

Eyler, James, S. Olin Garrison, Beverly S. Richards, Harriet Slavoff, and Darla Timberman. *Borough of Elmer 1893–1993.* Elmer, NJ: Elmer Centennial Committee, 1993.

Learn, Pauline Garrison. *A South Jersey Farm with Genealogy, History, and Recollections.* 1973.

Loper, George Garton III. *The History of Pittsgrove Township Including the Centerton Inn and Elmer.* Pittsgrove Township Historical Society, 1994.

Myers, Elizabeth Coles and Elaine Kline Myers. *Daretown and Vicinity.* 1991.

Richman, Mary Ann. "Elmer As Our Fathers Knew It." *Elmer Times.* Dec. 8, 1922.

Schalick, Arthur P. Jr. *Centerton New Jersey.* Pittsgrove Township Historical Society, 2003.

Swing, Gilbert S. *Biographical Sketches of Eminent Men. Events in the Life and History of the Swing Family.* Camden, NJ: Graw, Garrigues, and Graw, 1889.

Yoval. Alliance Colony Foundation, 2007.

INDEX

Discover Thousands of Local History Books
Featuring Millions of Vintage Images

Arcadia Publishing, the leading local history publisher in the United States, is committed to making history accessible and meaningful through publishing books that celebrate and preserve the heritage of America's people and places.

Find more books like this at
www.arcadiapublishing.com

Search for your hometown history, your old stomping grounds, and even your favorite sports team.

Consistent with our mission to preserve history on a local level, this book was printed in South Carolina on American-made paper and manufactured entirely in the United States. Products carrying the accredited Forest Stewardship Council (FSC) label are printed on 100 percent FSC-certified paper.

MADE IN THE USA